Historic England

Brighton & Hove

Kevin Newman

AMBERLEY

For Jake

First published 2019

Amberley Publishing
The Hill, Stroud, Gloucestershire, GL5 4EP
www.amberley-books.com

The publisher is grateful to the staff at Historic England
who gave the time to review this book.

All contents remain the responsibility of the publisher.

ISBN 978 1 4456 7340 0 (print)
ISBN 978 1 4456 7341 7 (ebook)

British Library Cataloguing in Publication Data.
A catalogue record for this book is available from the
British Library.

Typesetting by Aura Technology and Software
Services, India. Printed in Great Britain.

Contents

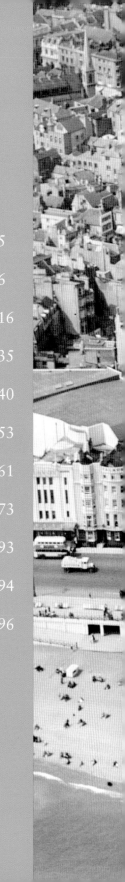

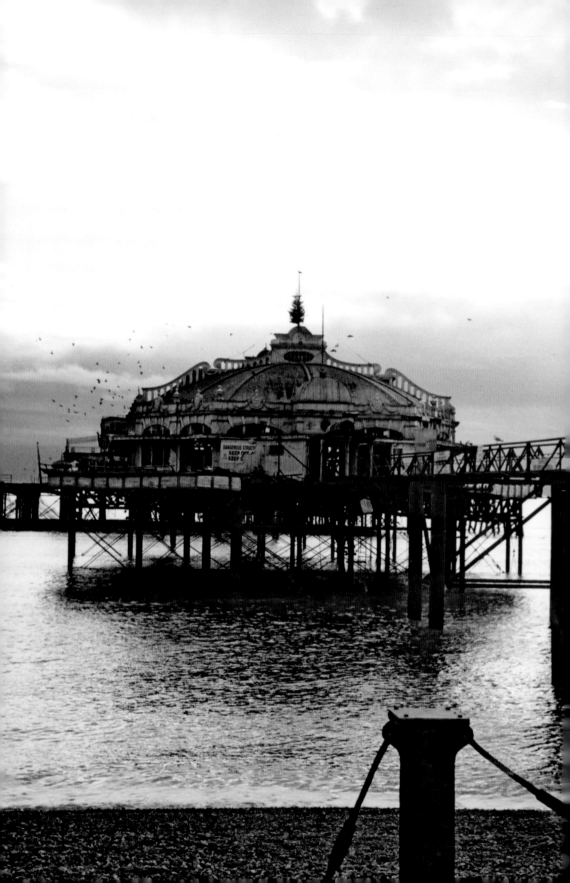

Introduction

The settlements of Brighton and Hove, which have been a unified city since 2000, have had more books about them than most seaside resorts, so the reader may want to know why another is needed. The reason is that for the first time the Historic England Archive of pictorial records have kindly granted this author access. *Historic England: Brighton & Hove* is the showcase of this unique combined resource of archive images. Using these images we are able to soar above the city of the past, then swoop down to examine it in more detail.

For me, this was a personal investigation. In the archive's aerial images I could see the place where I was born (years before the hospital block was built), the park I played in as a child, the pond I once fell in and the buildings and places of Brighton and Hove I know and love. It made me yearn for a Brighton lost – I would have loved to have walked on the West Pier in the 1960s, not the 1990s with a hard hat on, or to have seen the Metropole before its 1960s makeover, or even visit the old Churchill Square once more. Investigating the archive answered questions, set many more, and made me realise that though I don't live in the city anymore, it still holds a place in my heart.

To ensure we don't neglect Hove, we start generally from the west each time and travel east, or north when needed. If you've enjoyed a peek into this archive, you can access it for yourself at archive.historicengland.org.uk. And if that hasn't whet your appetite enough, then you should discover mybrightonandhove.org.uk, the Francis Frith Collection, the Royal Pavillion and Museum, Brighton and Hove's archive, the BFI or the Regency Society's James Gray Collection, as they are all worth a visit too.

Places to Play

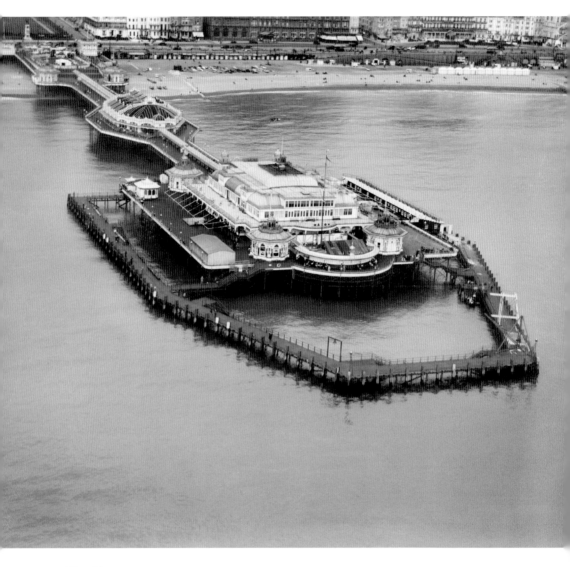

West Pier
In this image we see the West Pier in all its glory in the 1920s, the decade described in Patrick Hamilton's book *The West Pier*, a time when a walk on the pier and cocktails at the neighbouring Metropole Hotel were the height of sophistication. (© Historic England Archive. Aerofilms Collection)

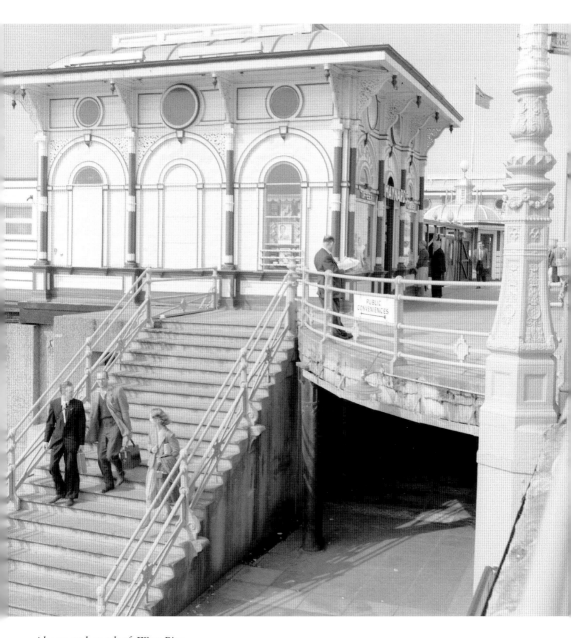

Above and overleaf: West Pier
Swooping down now to the pier's land end on the King's Road, we are looking west and upwards at the entrance kiosks, both of which have been recreated for the new i360 observation tower. The West Pier Trust offices have now moved into the beach huts on the level that people in this photo are walking up the steps from – the huts that once overlooked the nearby paddling pool. (Historic England Archive; author's collection)

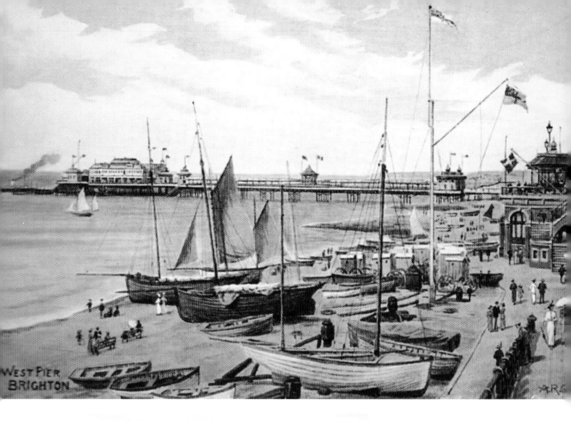

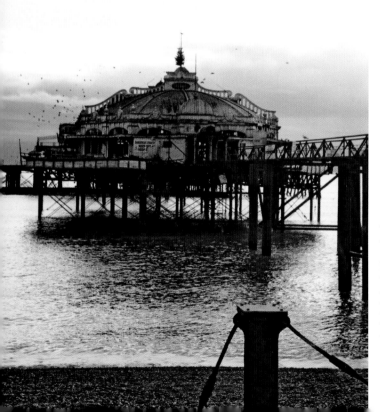

West Pier
The West Pier in its heyday
and looking forlorn in the
late 1990s, before the arson
attacks of the early 2000s
that would sound its death
knell. (Courtesy of Claudine
Smithers; author's collection)

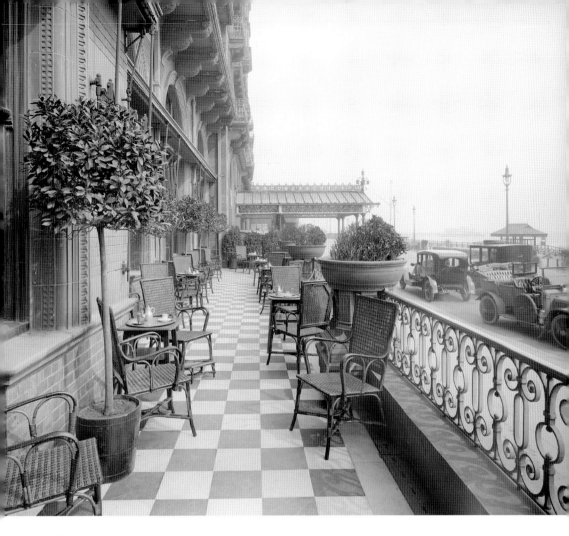

The Hotel Metropole, King's Road

One of the most enjoyable ways to spend your leisure time and take in the Brighton air must be sitting with a drink and looking across at the Brighton promenade and seafront. Here is a splendid place to do just this. The Metropole's terrace was the height of fashion from the hotel's opening in 1890 until the Second World War when the hotel was requisitioned by the RAF. The First World War (pictured here) was a very different story, though, with the hotel – and Brighton itself – busier than ever in the town's role as a hospital town and a place for fun seekers to escape the toil and misery of the war abroad. This photo was taken by the hotel's builders and first owners, the Gordon Hotels group, who presumably needed the images to show the grandeur of the hotel in a rare quiet moment. (Historic England Archive)

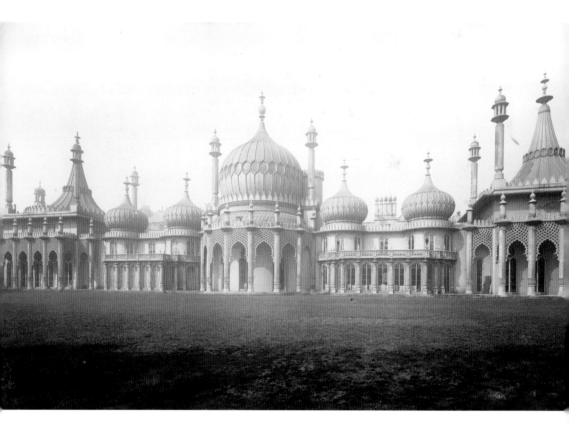

The Royal (Marine) Pavilion
The prince regent's (later to become George IV) decadent and highly ornate pleasure palace certainly was a place to play in for the extravagant prince; however, by the time it was completed in its Indianesque phase by 1822, as seen here, he was king and too old and busy for many visits to Brighton. He last visited his palace in March 1828, according to Chris Herelocks, by which time Brighton had become too busy for his liking, preferring the Royal Lodge in Great Windsor Park's privacy instead. It marked the end of his visits to his 'second home' of Brighton. He had first, in 1778, rented Brighton House from his chef, Louis Weltje, which was then developed into the Marine Pavilion by Henry Holland. Then once he personally leased the property in 1793, George could finally start to think about its final stage of development. Gaining the regency in 1811 meant that by 1815 the prince could employ Nash to add a banqueting and music room to the pavilion and an Indian-style exterior. Brighton would never look the same again, and the world gained a truly unique building. (Historic England Archive)

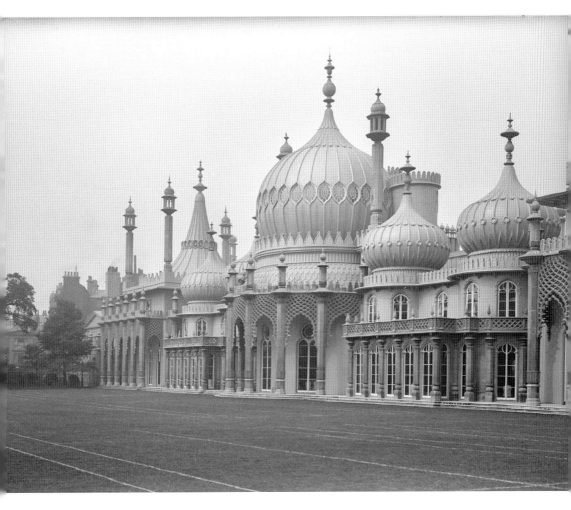

Above and overleaf: The Royal (Marine) Pavilion
In our second and later picture, dated to between 1920 and 1950, we see that little has changed
to the pavilion, as Brightonians took the palace more and more to their hearts. If this picture
is as late as 1950, then the palace would have recently witnessed the 1948 film *The First
Gentleman*, about George IV and shot in its grounds and buildings. (Historic England Archive)

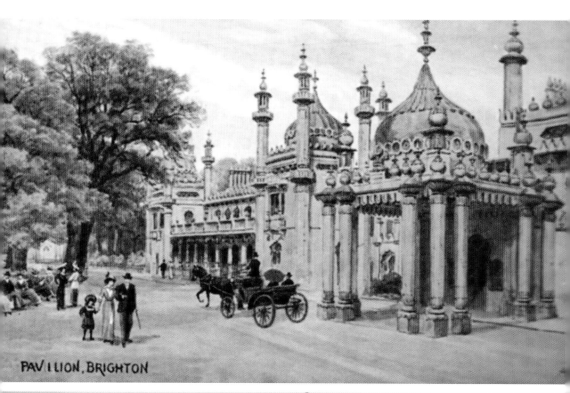

PAVILION, BRIGHTON

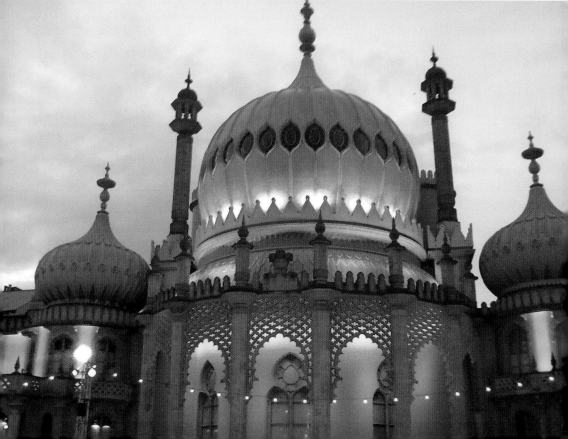

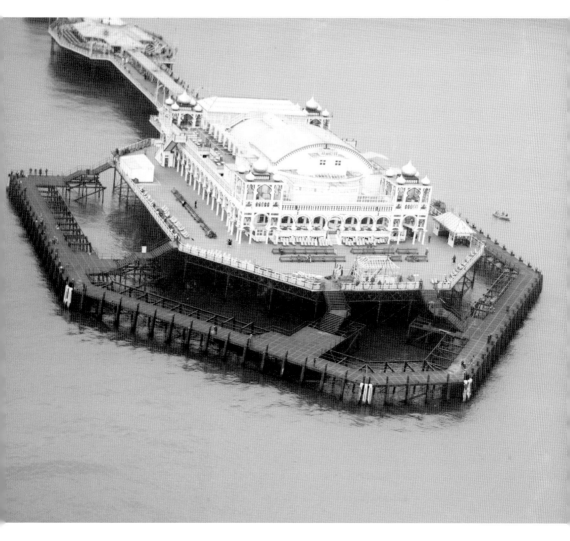

Above: Brighton (Marine) Palace Pier
Seeing the Palace Pier here complete with its fishing deck, reminds us of the pier's original use. Below the main deck was the pleasure paddle steamer embarkation point and this platform was also for swimming (originally for men). This pier is called the Palace Pier (the full name is the Brighton Marine Palace Pier) as it was nearer the pavilion, although it did also have a palatial theatre here on the southern end until former owners, the Noble Group, removed it following the 1973 boat crash that affected the pier. They promised to restore the theatre but never did, changing the sea end instead into an 'Alton Towers-over-water'. Interestingly, the West Pier's owners tinkered with the name 'Palace' as they had a palace-style building features too. (© Historic England Archive. Aerofilms Collection)

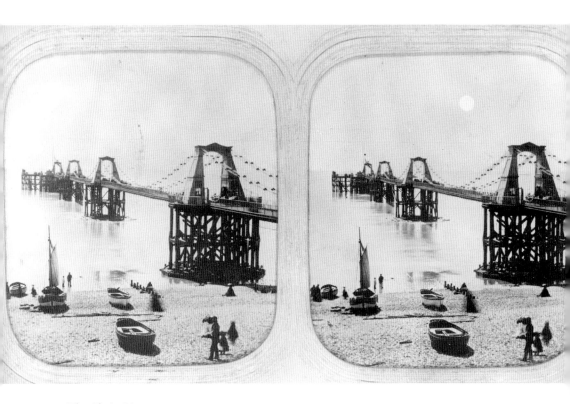

The Chain Pier

Here we have a stereoscopic view of Brighton's first pier, the Royal Suspension Chain Pier, to give it its full name. It was designed and built by Captain Samuel Brown who was a Royal Navy engineer and resident of Brighton. It opened in 1823 and survived seven decades until the pier was demolished after storm damage in 1896. Originally intended as a landing stage for cargo boats, it proved to be a popular promenade, which led to the introduction of refreshment kiosks and its eventual evolution to a pleasure pier. Painted by Turner and Constable, walked on by Victoria, Albert and William IV, and although not the first in the world, it is agreed to be the first pleasure pier, thus establishing the notion of a building for entertainment purposes and leisure walks above the waves. The expanded landing area, activities and shops here suggest this image was taken early on in the pier's life. Its shops did a roaring trade apparently in cherry brandy, gingerbread and silhouettes of those visiting the pier. (Historic England Archive)

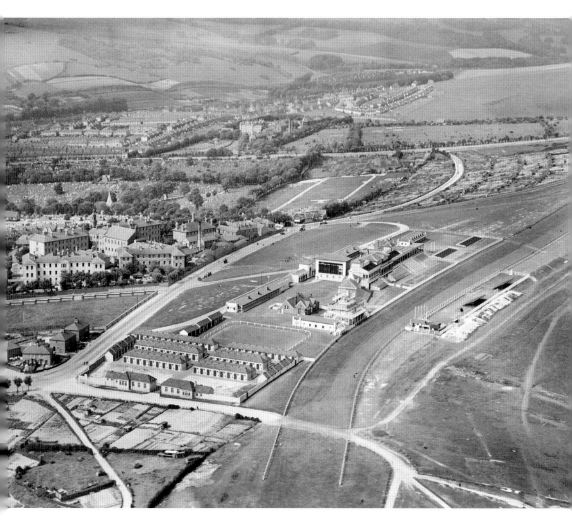

Racecourse Grandstand and Stables
Brighton Racecourse and stables had already existed for well over a century by the time this aerial photo was taken in 1933. Lewes Racecourse had provided entertainment for the gentry and aristocracy, but this crescent-shaped course at the top of Whitehawk Hill provided a nearer venue, with stables eventually being built in what is today Brighton Dome, at a height above sea level equivalent to the upper reaches of the i360. (© Historic England Archive. Aerofilms Collection)

Places to Stay

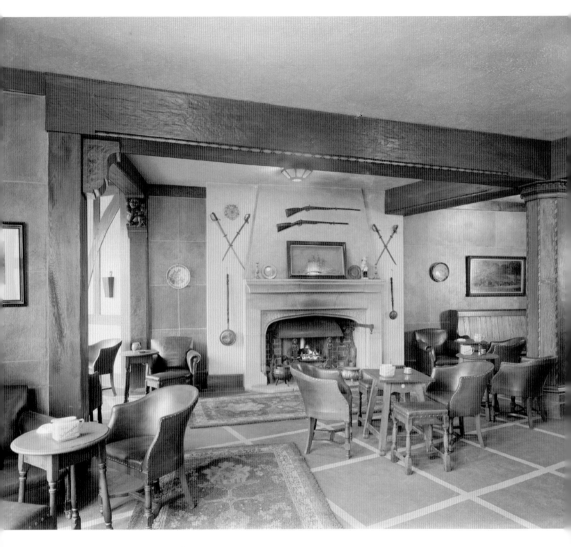

Above, opposite and overleaf: The Sussex Hotel
Starting again at the west end of the city, we peek inside the Sussex Hotel (which is still running today) at No. 17 St Catherine's Terrace. The hotel seems to have been used here by Liverpool-based company Ashby Tabb Ltd, furnishers and decorators, who appear to be using the interior of the hotel for marketing their products and services. We focus on the very best place of any hotel – the bar. (Historic England Archive)

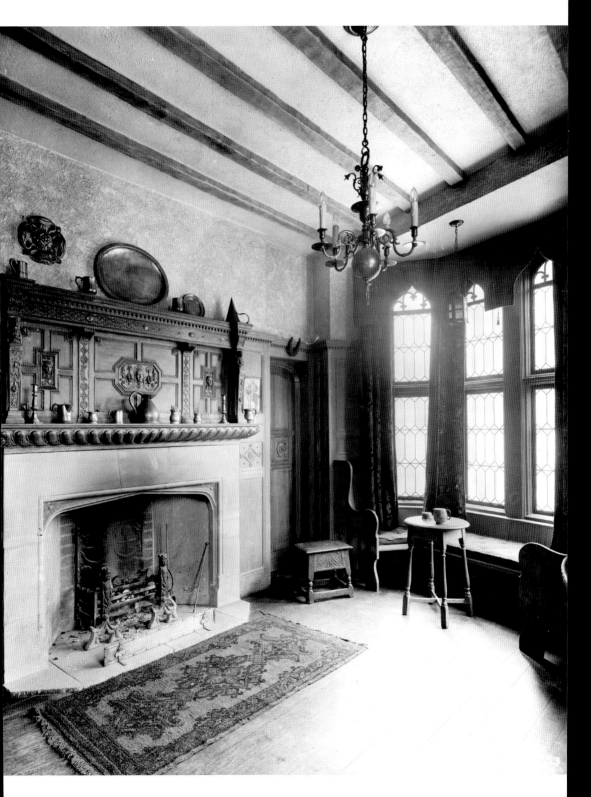

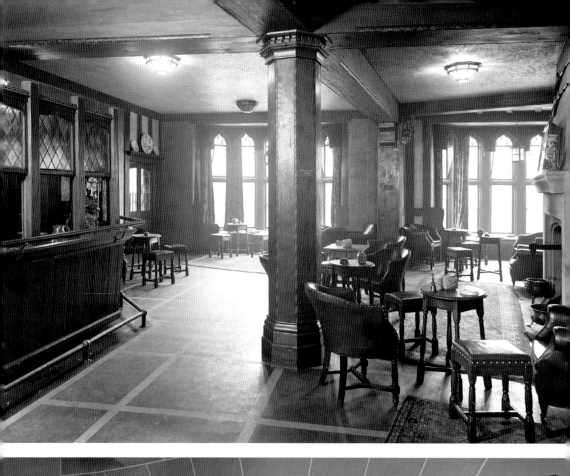

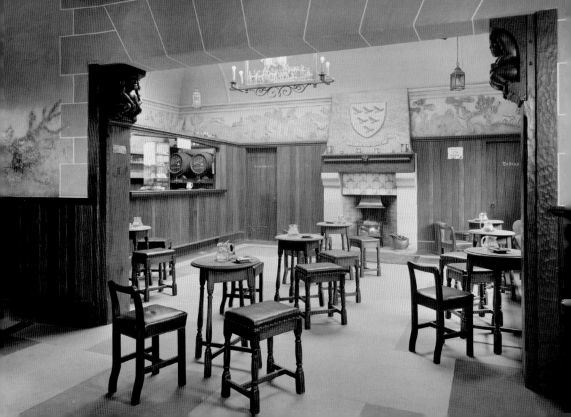

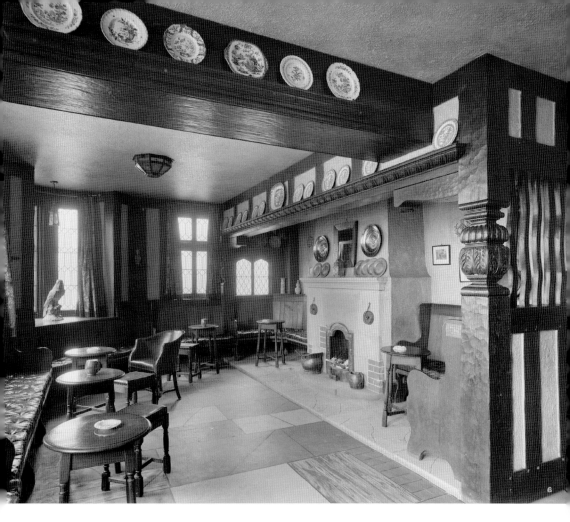

Above: The Paris Room, the Western Hotel

The Western Hotel is named after Western Road, on which it sits today. The Paris Room was a lively bar with a busy scene in live music and an eclectic clientele – even, as it says, for such a diverse city as Brighton and Hove. It was firstly the Western Tavern Inn and since this photo has been Finch's, Blimey O'Reilly's (in its Irish phase), and The Juggler. Here, back in 1927, we see another showcase for Ashby Tabb's furniture (note the inglenook fireplace here). Tabb's were probably commissioned to furnish the building following the alterations, plans of which were submitted in 1926 when local pub company Edlins were the owners. Edlins were well known for their extensive and creative rebuilds, the most famous of which is the fanciful King and Queen of Brighton. Edlins, who had owned the hotel since 1915, were less drastic here in their renovations. Thankfully the magnificent green copper dome is still atop the building and you can still see the 'Western Hotel' golden mosaic above the first floor, reminding us of its time as a hotel in the 1920s. (Historic England Archive)

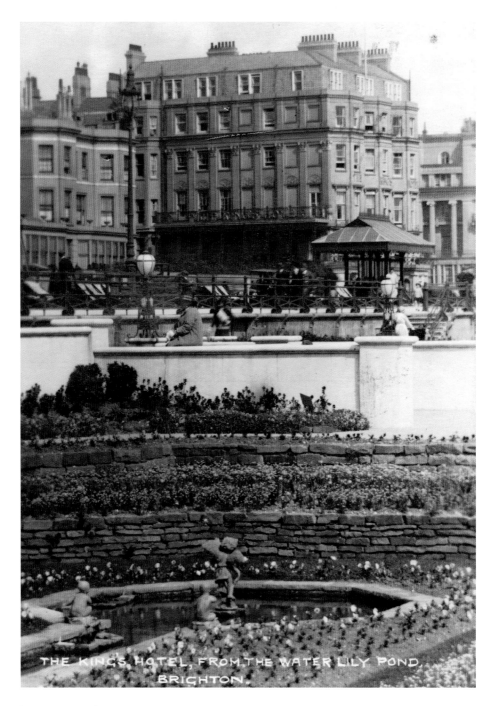

THE KING'S HOTEL, FROM THE WATER LILY POND, BRIGHTON.

The King's Hotel

Being a place frequented by royalty over the centuries, it is no wonder Brighton has had a Prince's Hotel, has a Queens Hotel, a King & Queen pub and here the King's Hotel. Here we see the hotel (which is still open today under the same name) back in 1928 when the King's Road between it and the promenade was yet to be deluged with traffic. (Historic England Archive)

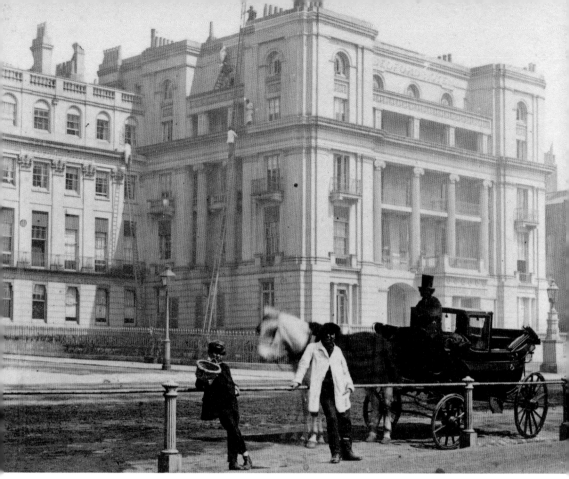

Above and right: The Bedford Hotel
The Bedford Hotel, built in 1829, stood on the corner of King's Road and Cavendish Place. It was demolished in 1964 after being destroyed by a fire. It was replaced by a seventeen-storey hotel block, which opened in 1967 partly as a new Bedford Hotel and partly as flats. Today the hotel is the Holiday Inn, after being owned by one-time Metropole owner Harold Poster and more recently the Hilton Group, who rebadged it as the Hilton Brighton West Pier. Here (above) we see a man and a boy leaning against a railing next to a horse and carriage on King's Road, with the south front of the original Bedford Hotel behind. Male figures, probably window cleaners, can be seen climbing up tall ladders around the hotel's exterior. (Historic England Archive; Author's collection)

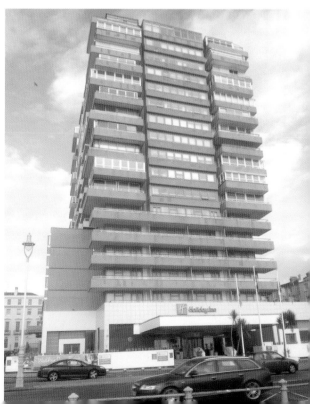

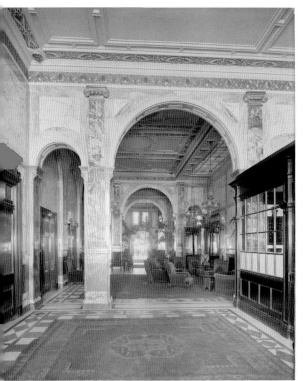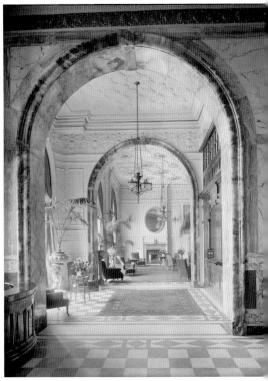

The Hotel Metropole (Hilton Brighton Metropole)
The Hotel Metropole is Brighton's biggest and, when built, brightest, boldest and most brash hotel. Designed by prolific and profitable Victorian architect Alfred Waterhouse, it was constructed between 1888 and 1890 and opened in July 1890. Breaking away from the iconic architecture of Brighton's rendered, cream Regency terraces, it caused astonishment with its daring use of terracotta and red brick and also its sheer size, which dwarfed its older five-star competitor, the Grand. Critics called it a 'monster hotel' and a 'station building', but it soon eclipsed the Grand as the place for royalty and the well-to-do, attracting monarchs, rulers and aristocracy. Here we see the Met in 1915 when its owners, Gordon Hotels Ltd (who built the hotel), ordered this set of internal photos. They were commissioned in 1915, presumably for advertising or perhaps in case one of the feared attacks by the German navy occurred and damaged the hotel's Victorian grandeur. (Historic England Archive)

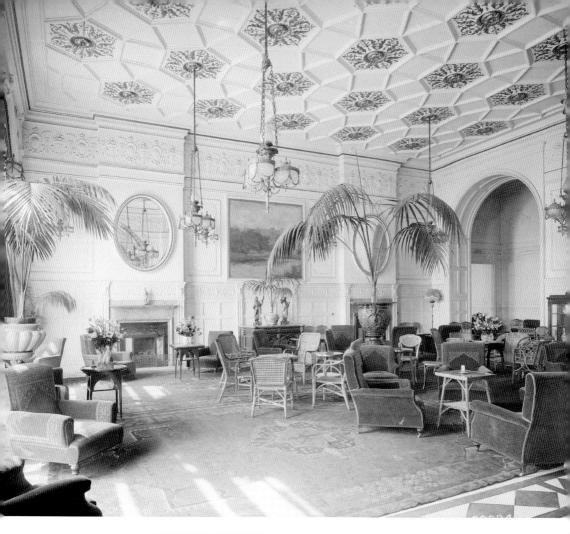

Above: The lounge at the Hotel Metropole – west of the entrance, at the front of the hotel. (Historic England Archive)

Right: The lounge at the Hotel Metropole, looking towards the entrance. (Historic England Archive)

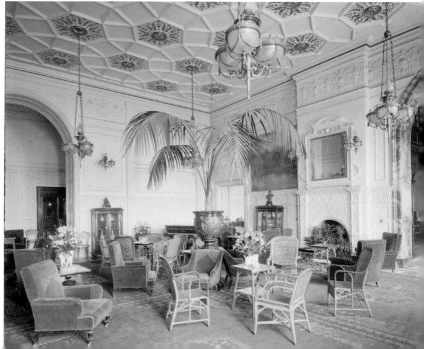

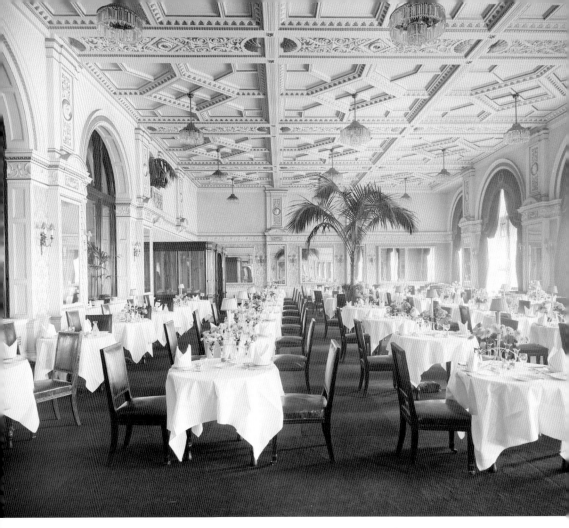

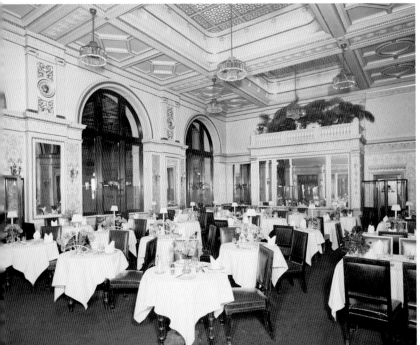

Above: The grand salle (the main and front dining room) in the Hotel Metropole. This is still recognisable today. (Historic England Archive)

Left: The centre dining room in the Hotel Metropole. Today this is called the Ambassadors Suite. (Historic England Archive)

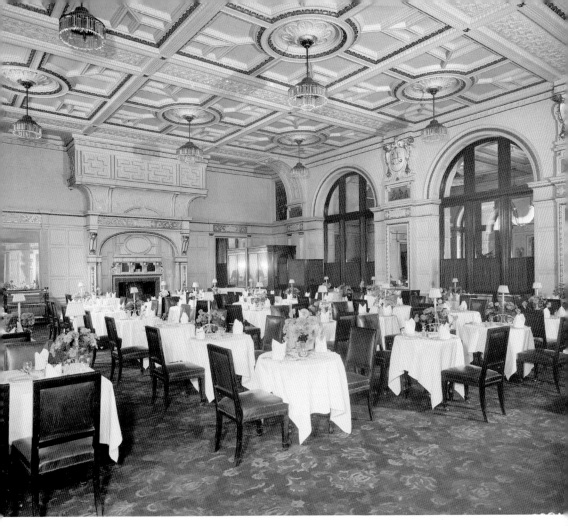

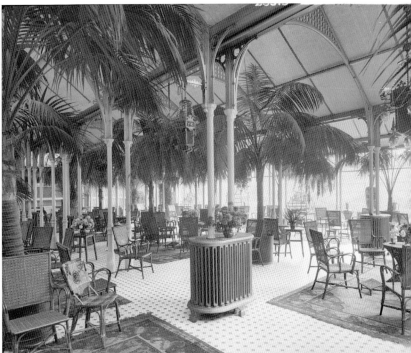

Above: The coffee room in the Hotel Metropole, located behind the centre dining room and to the south of the Winter Gardens. (Historic England Archive)

Right: The Winter Garden in the Hotel Metropole, looking towards the windows. (Historic England Archive)

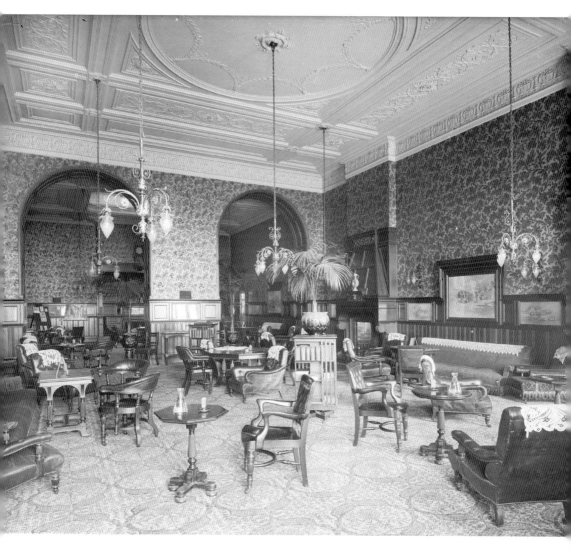

The smoking room in the Hotel Metropole. This was assumed to be west of the main entrance at the front of the hotel, but the darker wallpaper suggests it may have been somewhere further north in the building, though still on the western side of the hotel. (Historic England Archive)

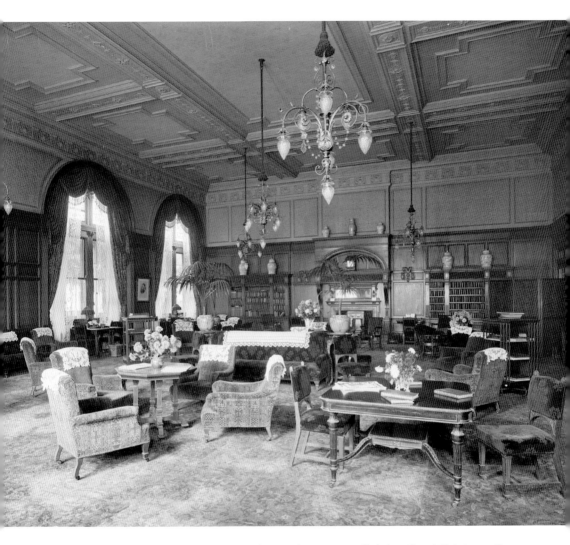

The library and reading room of the Metropole. Another room, called the Churchill Suite until recently, has also been the hotel's library, but this room appears to be on the far west side of the front of the hotel, where the actual bar of the Metropole Bar is today. (Historic England Archive)

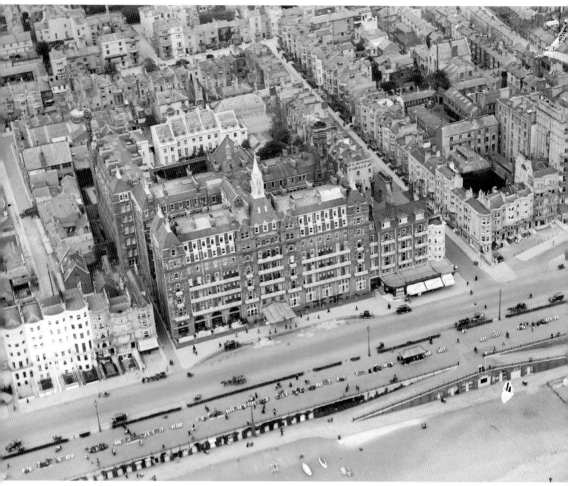

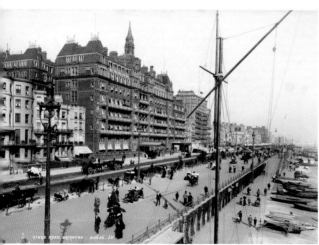

Above and left: The Metropole
Here we see the view of the Metropole
from the West Pier as we zoom down
to road level. From its 1890 opening
until the 1930s the West Cliff part of the
King's Road here had eclipsed the area
further east around the Palace Pier, Royal
Albion and Steine as Brighton's most
fashionable area. A visit to the West Pier
and then drinks at the Metropole was the
occupation of the wealthy, whether Lord
Alfred Douglas as a child or the fictional
protagonist Ralph Gorse of Patrick
Hamilton's *The West Pier*. (© Historic
England Archive. Aerofilms Collection;
Historic England Archive)

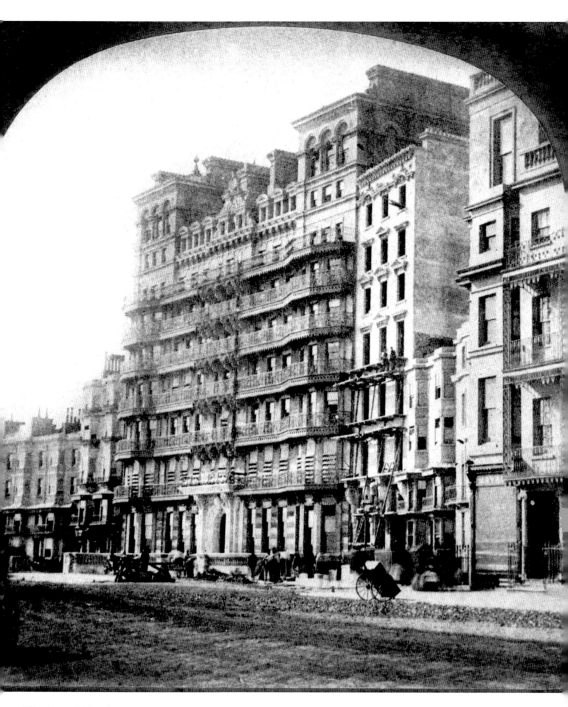

The Grand Hotel
The front of the Grand Hotel on King's Road, as seen from the south-east. The lack of a shadow from the larger, more westerly Metropole suggests this image is pre-1888, in the days when it was Brighton's biggest and most exclusive hotel, with no competition from its nearby red-brick and terracotta rival. (Historic England Archive)

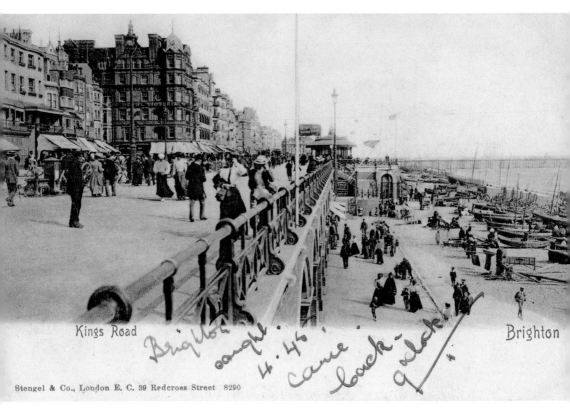

Kings Road Brighton

Stengel & Co., London E. C. 39 Redcross Street 8290

Above, opposite and overleaf: Orleans Residential Club (Brighton Harbour Hotel)
The Metropole was often said to be Brighton's first large building using red brick and terracotta, but the Brighton Harbour Hotel, constructed in 1883 on the corner of West Street and King's Street, pipped it by seven years. Before being part of the Harbour Hotels group, it has also been a backpackers' hotel called Hotel Umi, the Victoria Hotel and the Belgrave Hotel. Here we see it in its earliest guise, two years after construction and before its red exterior was painted over with the white and cream colour it shows today. It is definitely one of Brighton's most elaborately decorated Victorian buildings, with the architect Thomas Lainson (who also designed Hove Museum and Middle Street Synagogue) providing more intricate detail and creativity of design than either the Grand and Norfolk that came before, or the Metropole that came after. Viewed firstly here from the south-west, we see it as the Orleans Residential Club, with Marx Brothers' Jewellers on the ground floor as well as Sweetings Store. The second, slightly earlier image, is taken from the other side of West Street where a similar-looking building existed before its demolition and replacement by the Kingswest building. (Historic England Archive; Author's collection)

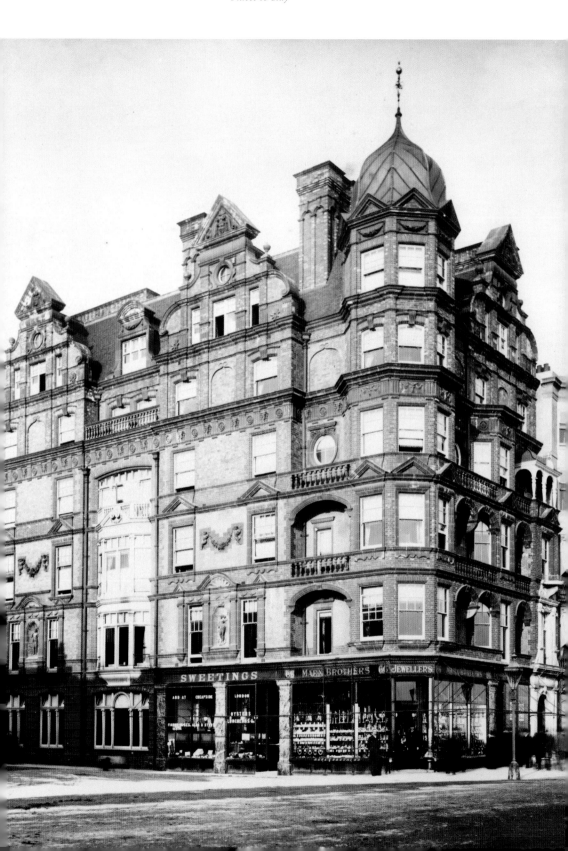

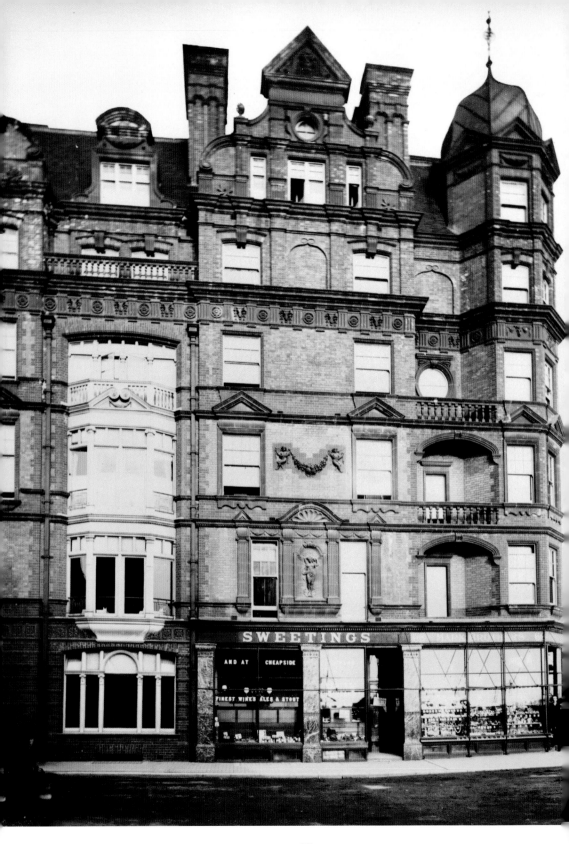

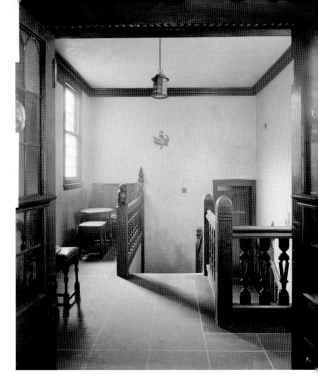

Right, below and overleaf above: Mortons Hotel
Today the Hope and Ruin pub in Queens Road, the ground floor of this pub has been redeveloped and the pub alone renamed numerous times just in this author's lifetime, so it is hard to recognise the ground-floor bar shot here. The road from the station to the sea made an obvious choice for inns and hotels, but today, save for one major hotel chain, Brighton's hotels on this route are stationed south of the clock tower where Queens Road becomes West Street. Here Mortons is being used to showcase Ashby Tabb furniture, so the later 1920s seem to have been a successful time for them in Brighton and Hove. (Historic England Archive)

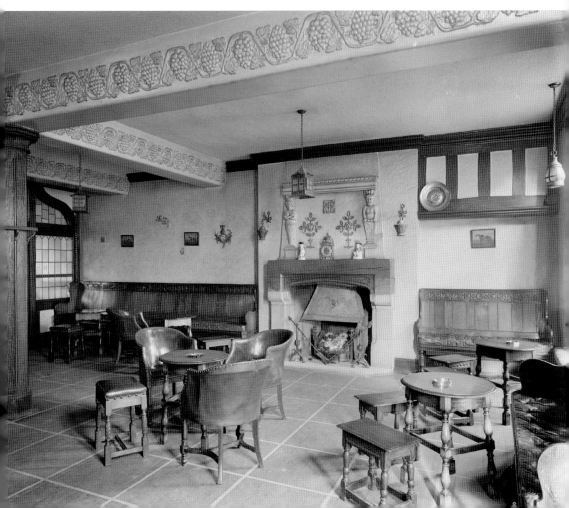

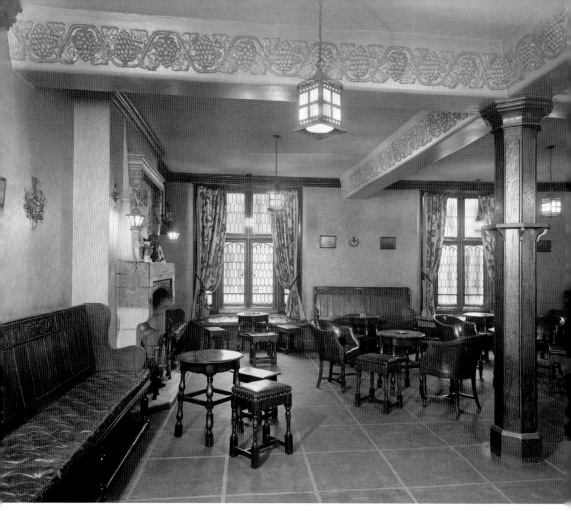

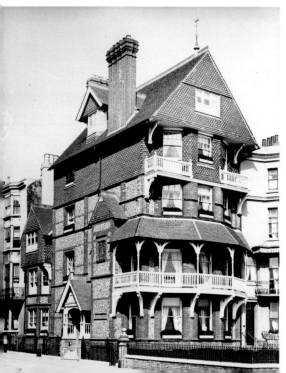

Left: The Lanes Hotel, No. 70 Marine Parade
Moving from west of the Steine to Brighton's
East Cliffs, we see here the early days of
what is now the Lanes Hotel. It is named
after Brighton's oldest and narrowest streets
and is situated to the east of the Palace Pier,
providing great views of the pier from its
location at No. 70 Marine Parade. Here we
see the hotel from the south-west in April
1885. The image shows the building after late
Victorian remodelling by the architect R. W. Edis.
(Historic England Archive)

Places to Live

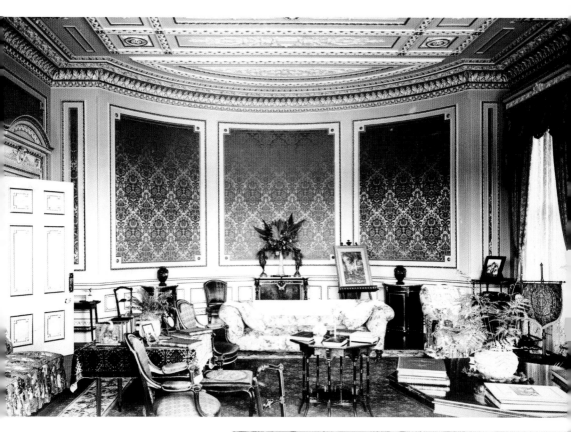

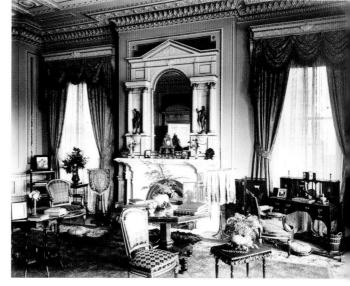

Above and right: Grand Avenue Hove's grandest street truly lived up to its name until the redevelopment of the later large houses on its west side into tower blocks. It still has an air of grandeur today, with its sea view and 70-foot-wide streetscape, and the way the noble route takes you up to Dyke Road, north of the town.

Here we start with the interior views of the sumptuous drawing room at No. 1 Victoria Mansions, Grand Avenue. The interior designer is listed as 'C. E. Birch' and the images were taken for James T. Chance, the owner. (Historic England Archive)

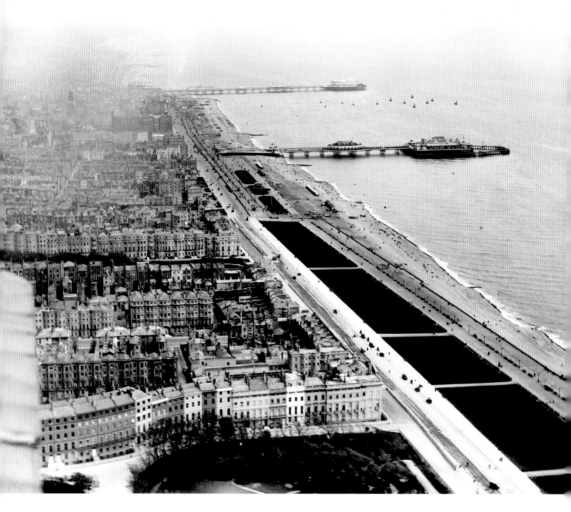

Above: Brunswick Lawns
(© Historic England Archive. Aerofilms Collection)

Opposite above: Brunswick Square
(© Historic England Archive. Aerofilms Collection)

Opposite below: Junction of Brunswick Terrace and Brunswick Street
(Historic England Archive)

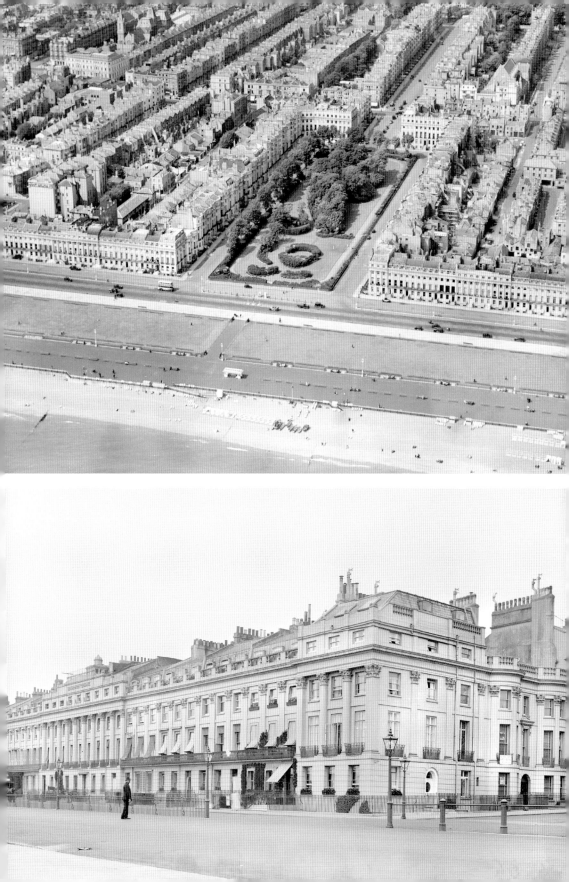

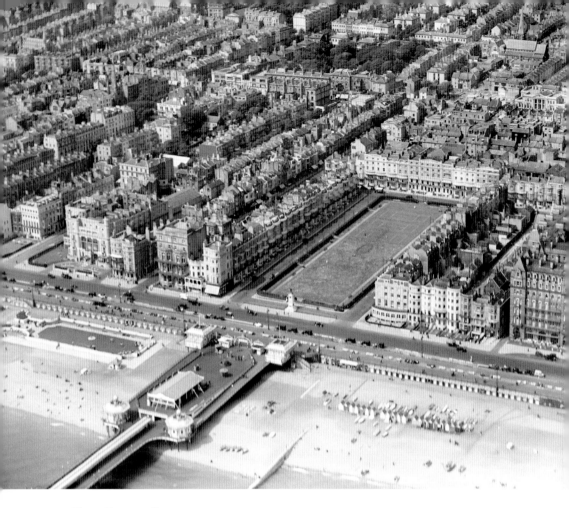

Above: Regency Square
(© Historic England Archive. Aerofilms Collection)

Opposite above: Moulsecoomb Estate
Moulsecoomb estate is seen here under construction in 1933. (© Historic England Archive. Aerofilms Collection)

Opposite below: Whitehawk Housing Estate
The Whitehawk housing estate is seen here under construction in 1933. Brighton Racecourse can also be seen. (© Historic England Archive. Aerofilms Collection)

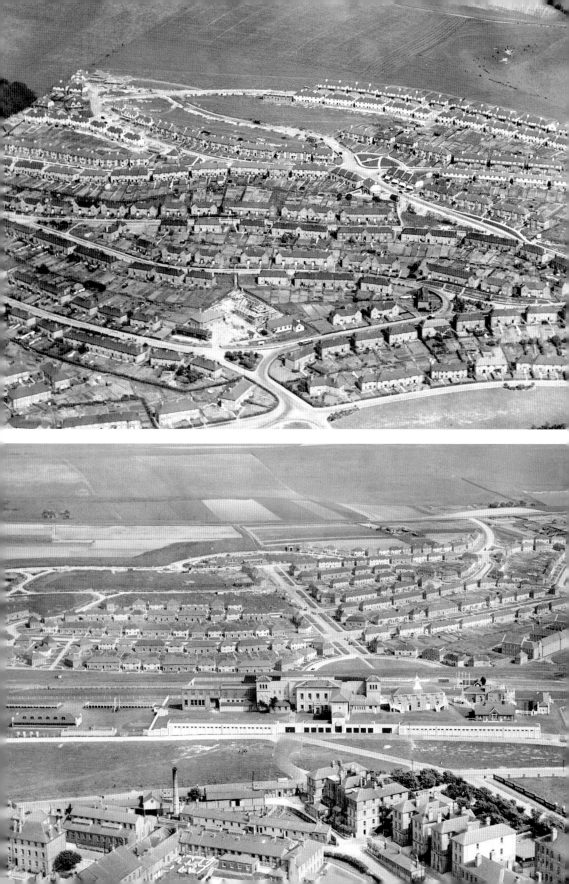

Places to Love

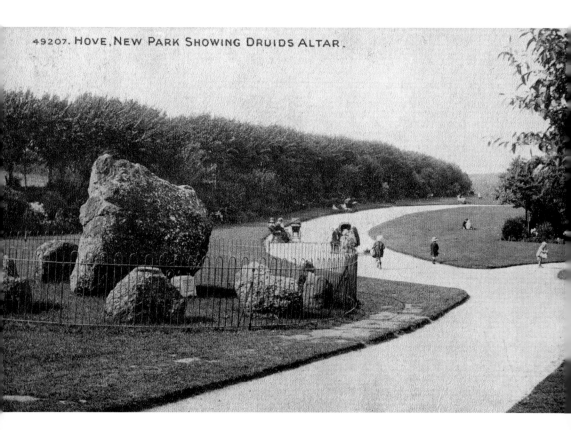

49207. HOVE, NEW PARK SHOWING DRUIDS ALTAR.

The Goldstone, Hove Park

The Goldstone is a place to love for several reasons and it is an unusual geological feature for Sussex. Originally in a different spot south of the A270 and east of Sackville Road. Weighing apparently 20 tons, the Goldstone is a remnant of sandstone and flint that was left after the erosion of the much softer terrain around it. Legend has it that a clump of the Downs was kicked by the Devil, as he tried to break through the hills by digging a route for the sea to flood the pious and godly people of the Weald. Its supposed use by druids led to it being known as the 'Druid's Altar', and by 1834 its original home had changed from a remote lawless area to a popular tourist spot. So popular, in fact, that in that year the farmer who owned Goldstone Bottom had it buried, where it remained until 1900 when it was brought to the new Hove Park by Councillor Hollamby, who located and excavated the rock. As we see here, it became a major feature of the new park and the newly created Brighton and Hove Albion's first proper ground took its name from the rock and the area. The Goldstone Ground was demolished in 1997 and the rock today, which is across from the ground's former location, reminds us of this much-loved sporting site. (Historic England Archive)

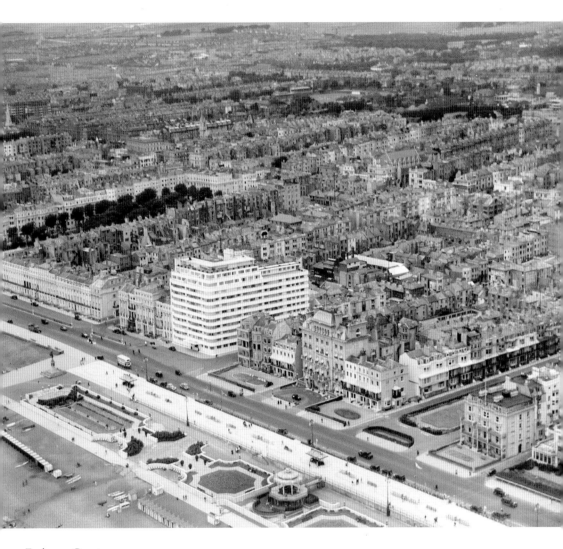

Embassy Court
This 1937 image of a building much loved today shows just how much the modernist design stuck out two years after it had finished being constructed – its white-rendered concrete in comparison with the cream-coloured decorative stucco fronts of the surrounding Regency designs, which its style of building was meant to replace. The building, which was designed by Wells Coates, has received criticism for not fitting in with its Regency neighbours, but people have come to love it, and there was even a campaign to save and restore it by 2006. (© Historic England Archive. Aerofilms Collection)

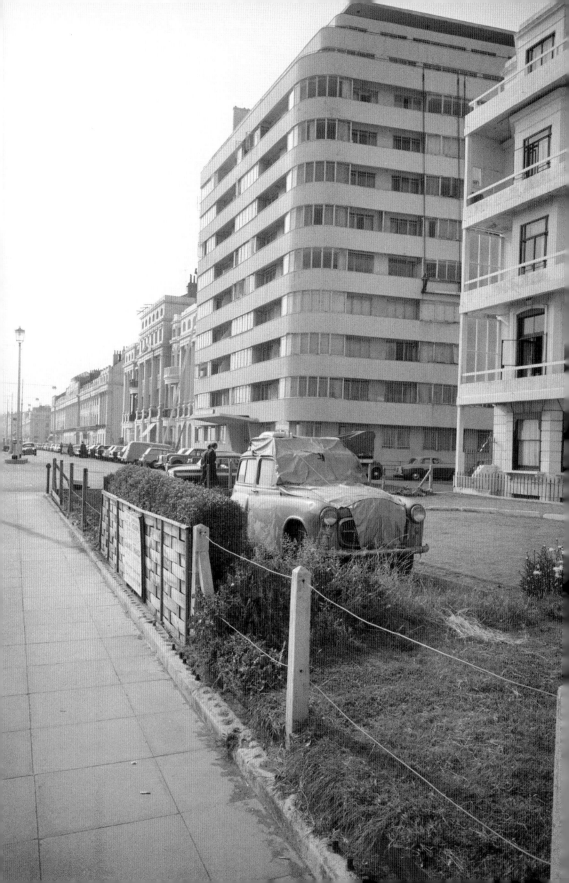

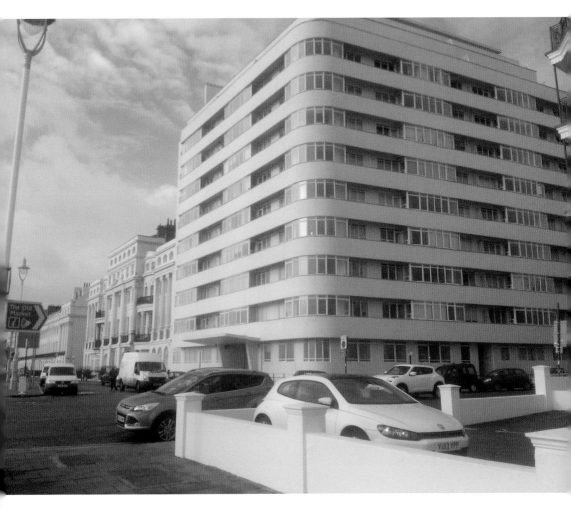

Above and opposite: Embassy Court
It is hard to see here but the block of flats is L-shaped, with twelve storeys fronting King's Road in the south and Western Street to the east. The glazing on the façade is almost continuous, and the ninth to eleventh floors are set back and staggered from the main fronts. The building is concrete with a plaster finish and a flat roof. The cars suggest the image opposite is from the mid-1960s. Today tours of the block are available during the Brighton Fringe Festival. (© Historic England Archive; Author's collection)

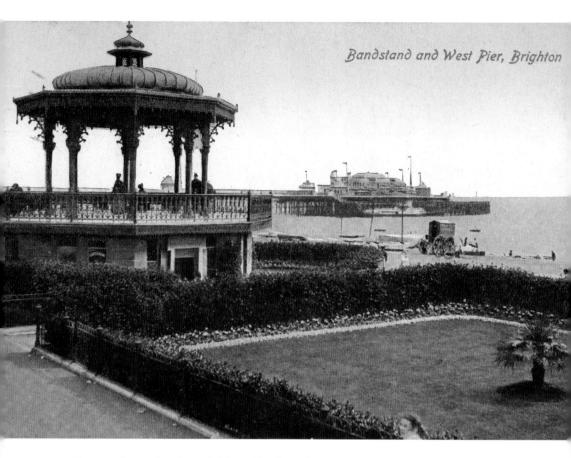

Bandstand and West Pier, Brighton

Above and opposite above: Brighton Bandstand

Brighton's seafront bandstand, located west of the West Pier, is the oldest in the country (built in 1884). It is also a rare survivor of its type as there were once thirty-six in Sussex and are now only nine. This might be because it has been described as 'all-but bomb-proof'. It has also been voted the best in the country by bandstand enthusiast and expert Paul Rabbitts, who has written a book about bandstands. He said in an interview with the *Argus* that he liked 'the detailing of it, the design of it, the location is just incredible, the fact that there is a little coffee shop behind it, the fact you can get married in it'. He is right. What makes it unusual is that it is one of the council's licenced marriage venues. Rabbitts also liked the fact that our bandstand is unusual as it is 'right on the seafront', whereas most others are on promenades or in parks. This First World War era postcard shows us the picturesque juxtaposition of the bandstand in the foreground and the West Pier behind. (Historic England Archive; Author's collection)

Opposite below: Pool Valley and Environs
(© Historic England Archive. Aerofilms Collection)

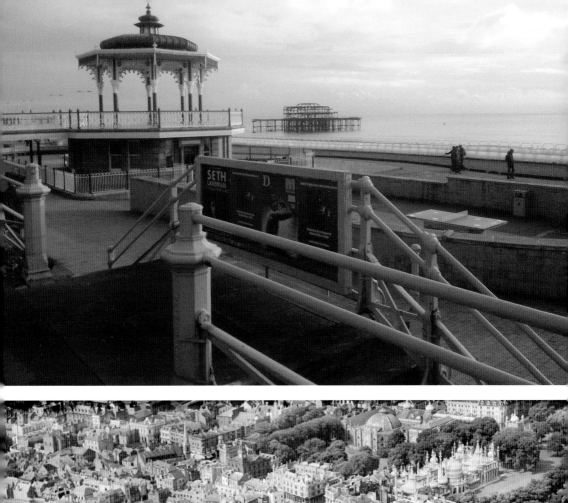

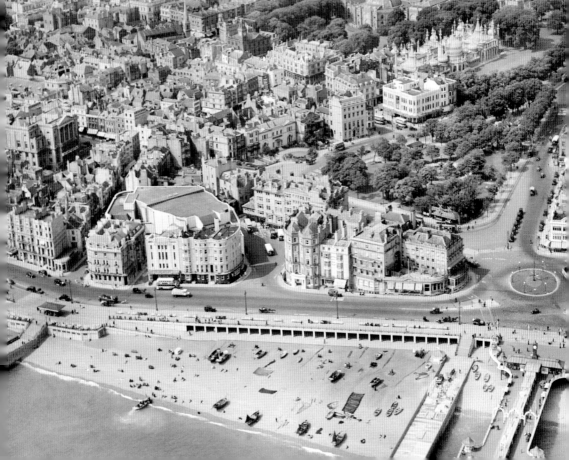

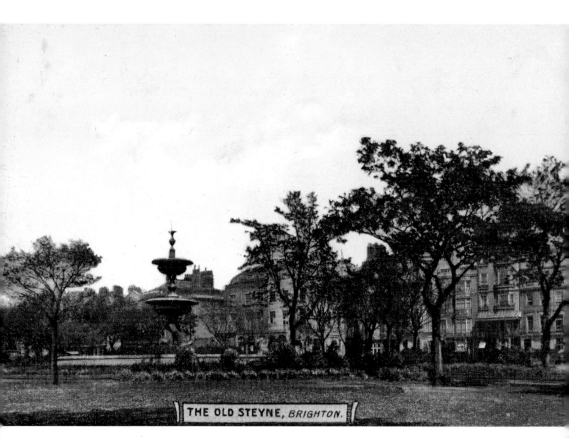

THE OLD STEYNE, *BRIGHTON.*

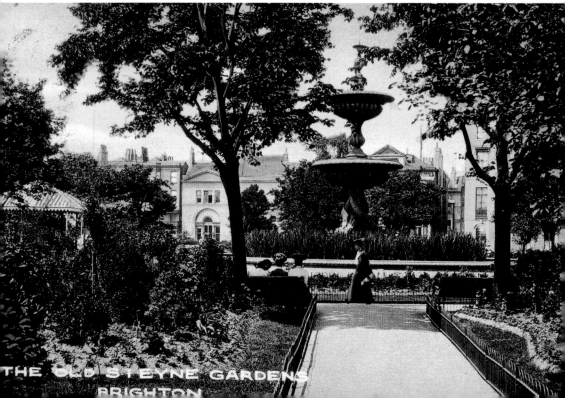

THE OLD STEYNE GARDENS
BRIGHTON

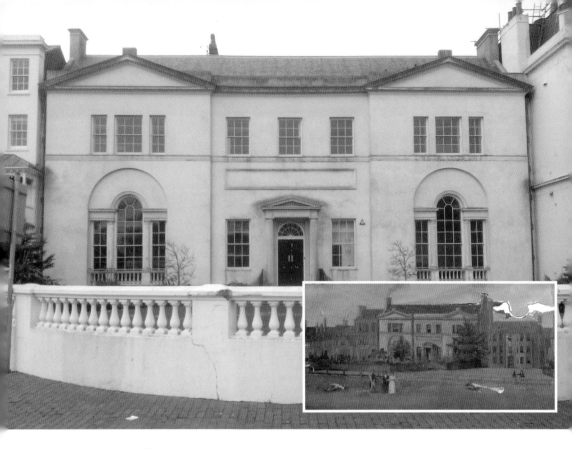

Above: Marlborough House

Marlborough House today. Marlborough House was first built in 1769 and in its first incarnation was the first house on the Steine. It was purchased by the Duke of Marlborough, who bought it in 1771. It was then purchased off the duke by William Hamilton MP in 1788 and transformed by the architect Robert Adam to its current, stucco-covered state. This meant that Hamilton and Prince George competed at this time in Brighton's history to see who had the town's most splendid house. Not many houses can be said to have competed with a royal palace-to-be! One last fact is that there was more than one Marlborough House in Brighton. The duke moved in 1778 to Grove House, where the Pavilion's music room is today, and this house also took the duke's name. This red-brick building was demolished as the Pavilion expanded and so we today just have the one, rather wonderful, Marlborough House. (Author's collection; RPAM BAH archive)

Opposite: The Steine

Here is a view of the Old 'Steyne', as it is spelt here, from the south looking across to the Victoria Fountain and the buildings on the (later built) eastern side. The Steine was Brighton's most fashionable address before the seafront became in vogue, and the earliest buildings still face into this green area – the fashionable would promenade here rather than on the seashore. The fountain was one of eminent Brighton architect Amon Henry Wilds' last creations, made to celebrate the queen's birthday. The stones the area got its name from ('Steine' means 'stony ground') were gathered together to form the base. Wilds, his father and father's partner are responsible for the building of many of Brighton's most architecturally significant buildings, such as the whole of Kemp Town, Brunswick Square and Adelaide Crescent. Our second view of the Steine looks from the west side across the fountain to Marlborough House. (Historic England Archive)

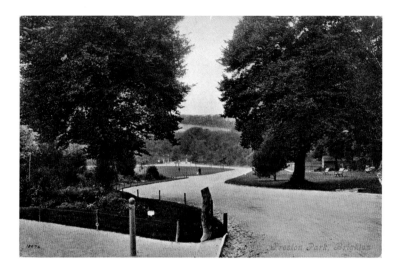

Above, below, opposite and overleaf: Preston Park

Heading north now to what once the estate of Preston Manor. Preston (originally Brighton) Park was purchased from the Stanford-Bennetts, who owned Preston Manor, for the people of Brighton by the bequest of £50,000 in the will of Brighton bookmaker William Davies. The park opened in 1883. Here (above) we look across the park to the north-west where the London Road/ Preston Road runs, today a constant throng of traffic in and out of the city. The layout of the paths in the park we see here (especially the main 'corkscrew' path) has been straightened and reduced in width since this photo was taken and the vista has been changed with the reduction of the flower beds on the left of the photo by the tennis courts. At 67 acres, Preston Park remains Brighton's biggest ornamental park and includes also Britain's oldest velodrome in the north-east corner, which opened in 1877. The second image (below) shows the original park railings that enclosed the park and its north-west entrance from a narrower London Road/Preston Road. Our third and fourth images (opposite) are of the rose garden at the Stanford Avenue entrance to the park, looking very well kept. The café at the end of the garden has changed its name from the first image (dated 1920–40) where it is called the 'Tea Chalet' to the 'Rotunda' in the second image, dated up to 1950. (Historic England Archive; Author's collection)

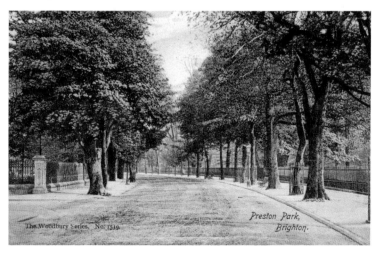

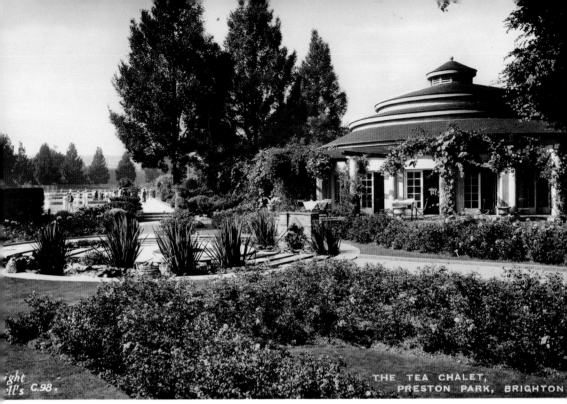

THE TEA CHALET,
PRESTON PARK, BRIGHTON

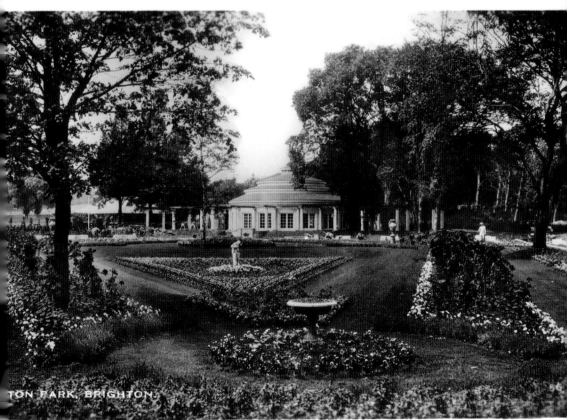

TON PARK, BRIGHTON

49

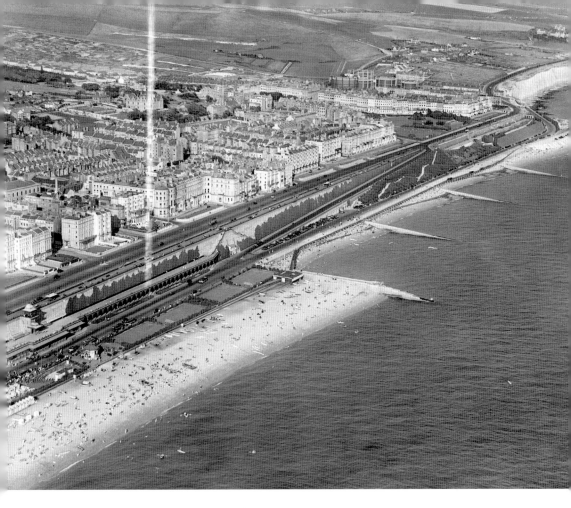

East Brighton, Kemp Town and Volk's Railway

Looking carefully, here we can see that back in 1932 coastal deposition and increased groyne construction hadn't yet allowed the eastern beaches towards Black Rock to grow to the extent they have today. The result is, if you look closely, you can see the original Volk's Railway, which operated much closer to the sea. Twenty years earlier it had been possible to walk underneath the railway in far more places than you can today. (© Historic England Archive. Aerofilms Collection)

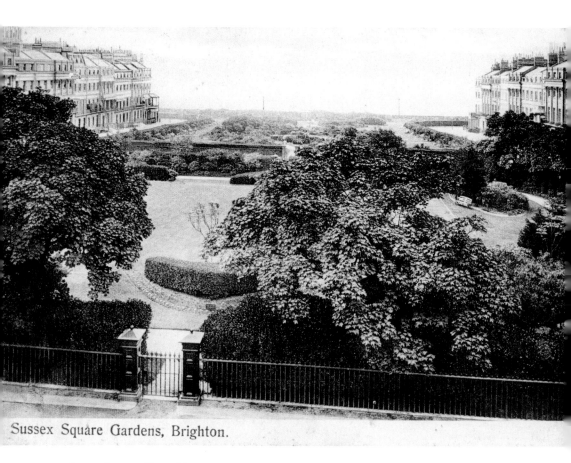

Sussex Square Gardens, Brighton.

Sussex Square, Kemp Town
(Historic England Archive; Author's collection)

Places of Work

Dr Richard Russell of Lewes brought his surgery down to Brighton's Steine so he could supervise the range of seawater treatments he had recommended in his book. Russell was neither the first nor the last physician to do so, but he was the one to attract the brothers of George III down to Brighton, followed by their nephew, the future George IV, making Brighton's future much more rosy. Today the sea has been pushed further south and the site of the surgery is that of the Royal Albion Hotel.

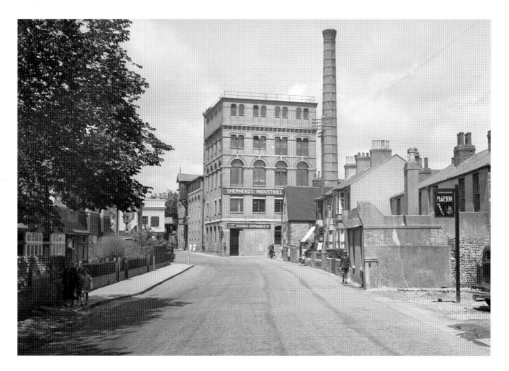

Breweries
This High Street brewery was constructed in 1881–82 and supplied 'celebrated Southdown ales', being taken over by the Mews family of brewers three years later. They sold it briefly to the Kemp Town Brewery before another local brewer, Smithers & Sons Ltd, who took it over in 1919. The building originally had a more ornamental sloping roof before increasing demand led to a water tank being installed instead on the upper floor. Smithers & Sons were taken over by Tamplin, and Stanford & Sons brewed there until 1938 when they went bankrupt. The buildings then became a series of businesses, commencing with Shepherd's Industries and then Le Carbone from 1947, the former of which we see in this picture, which ended up being named Mersen until the firm pulled out. The decoration of hops, barley sheaves and the inscriptions 'D & S' and '1881' on the chimney still remind us today of its first incarnation as a brewery owned by Dudney & Sons. (Historic England Archive)

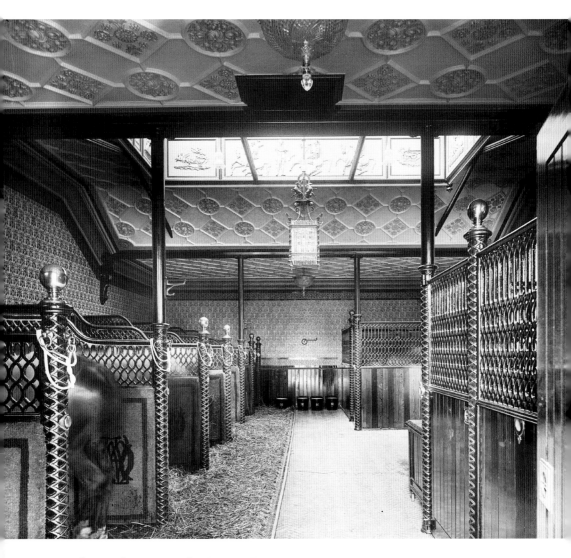

Above and opposite: Palmeira Mansions
Heading east to Hove, we are reminded here that until the twentieth century houses needed to accommodate our four-legged equine friends. Roads today with 'Mews' in the name were focussed on the housing of horses. Here, at the rear of No. 33 Palmeira Mansions in Hove's Church Road, we see that the luxurious accommodation humans enjoyed in the buildings was also continued in the stables too with elaborately decorated stalls. The stables are incredibly clean and lavishly decorated with wallpaper, brass and decorative plasterwork. No. 33 Palmeira Mansions was designed by architect H. J. Lanchester and built by Jabez Reynolds Jr in 1883–84, with interiors designed by F. H. Osler. The house was occupied by A. Mason. The second picture (opposite) is the equally elaborate saddle room. (Historic England Archive)

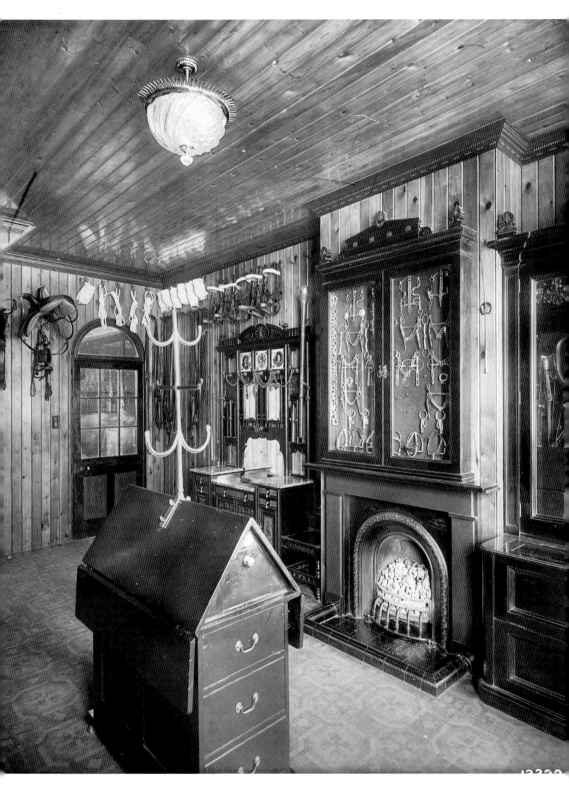

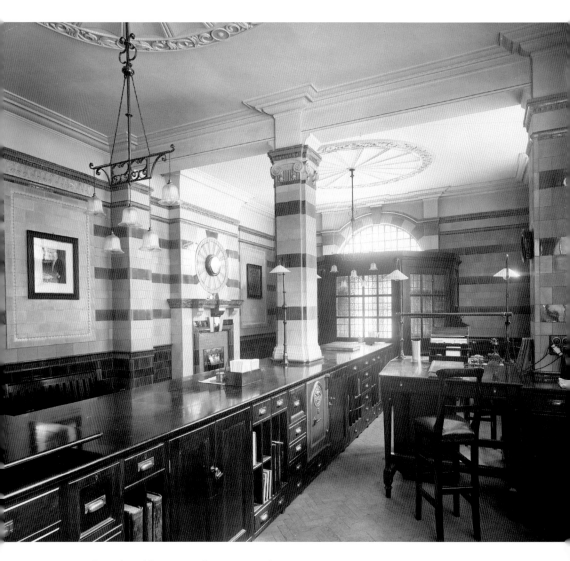

Prudential Buildings, North Street, Brighton
One of the Victorian and Edwardian era's most profitable and incredibly prolific architect Alfred Waterhouse graced our city with three buildings to work in. The Metropole, Hove Town Hall and, here, the Prudential Buildings in North Street were all Waterhouse buildings with his trademark terracotta and red brick. Sadly, of the three only the Metropole still exists. The Prudential Buildings housed the town's branch of the insurance company that existed on the busy thoroughfare from 1906 to 1967, when it was sadly demolished. One employee of the Prudential talks of her experiences between 1962 and 1966 on the My Brighton and Hove website, where she recalls being stuck in its ancient lift between floors. To see the exterior of this much-lamented building, do take a look at this fantastic website. (Historic England Archive)

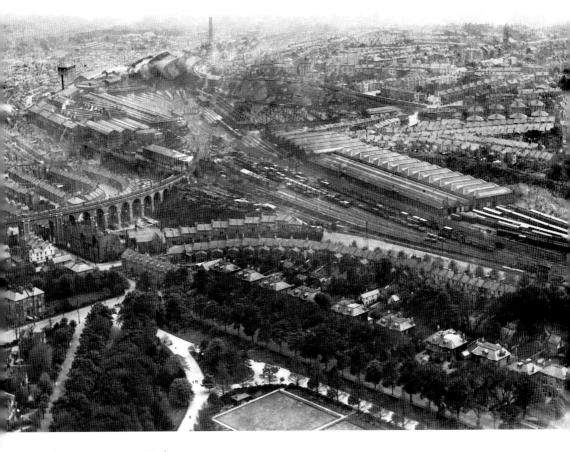

Brighton Locomotive Works
Moving north up the western valley of Brighton that forms London and Preston Roads, we notice how the railway works dominate the upper-western plateau of the valley. Despite the noise and smoke the wealthy villas on the west side of Preston Park, looked down upon by the residents of less-affluent Dyke Road Drive, curve behind up to Dyke Road. Today London Road separates the land where these villas were, which have now mostly been replaced by offices. (© Historic England Archive. Aerofilms Collection)

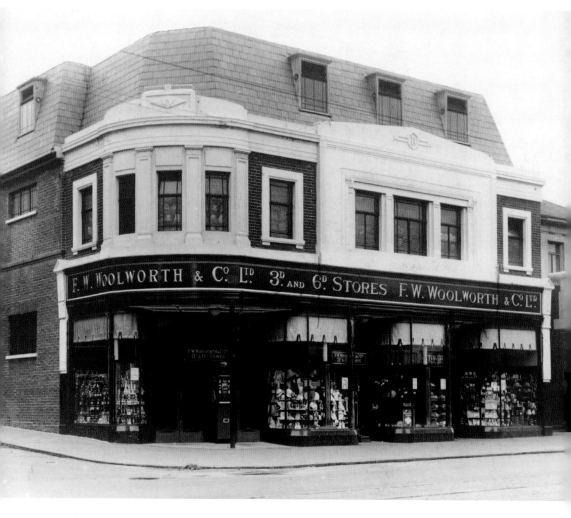

Above: F. W. Woolworth & Co., London Road
To the east of the railway works in London Road, at the bottom of the valley and Cheapside, is the glorious 1920s/1930s incarnation of what is today the Aldi building, in a location dominated by traffic heading out of Brighton. Since F. W. Woolworth & Co. had their store here at Nos 27–31 London Road, the site has also hosted Sainsbury's, followed by Aldi. Woolworths moved further north up the London Road to what had been Roslings store – that site today is a 99p store. (Historic England Archive)

Opposite: No. 50 St James's Street
This office scene merits inclusion just to demonstrate the luxury that offices offered here in 1921. This unusually shaped room has rich wood panelling. It still seems bare, though, when compared with the technology-heavy offices of today. No. 50 St James's Street is today subdivided into 50 and 50a, and is the site of the Western Union Money Exchange and the Property Shop. The photo was taken for W. A. Budd & Co., whose offices presumably were based in the building, which seems to have been a furniture warehouse based upon the number of photos of furniture taken for or by them in the archive. (Historic England Archive)

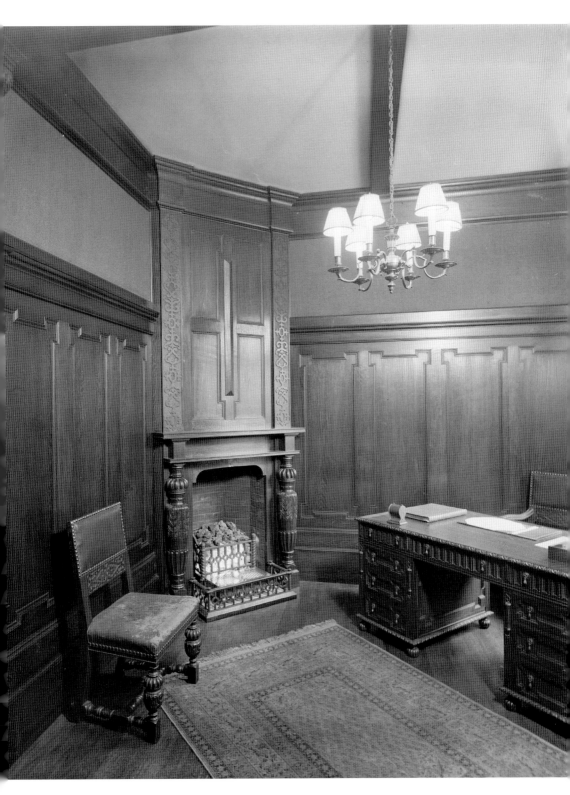

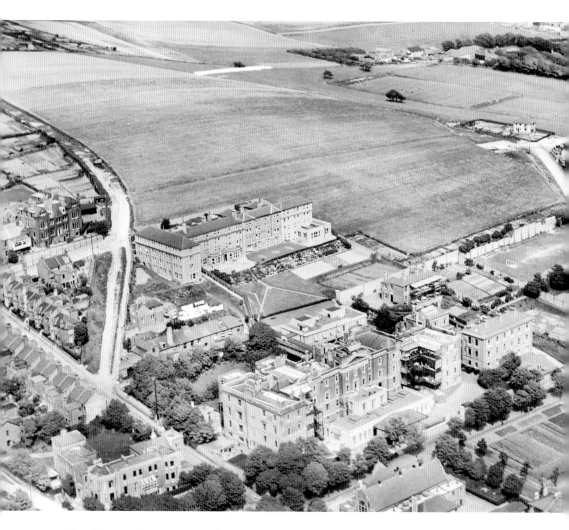

Royal Sussex County Hospital
Here we see the Royal Sussex County Hospital when the Barry Building was the epicentre of the complex. The Barry Building was designed by Sir Charles Barry, architect of not only St Peter's Church but also, a decade later, the Houses of Parliament. It is notable just how rural this scene still appears, with the estates above the hospital not yet built and the hospital taking up a fraction of its current layout. (© Historic England Archive. Aerofilms Collection)

Places to Learn

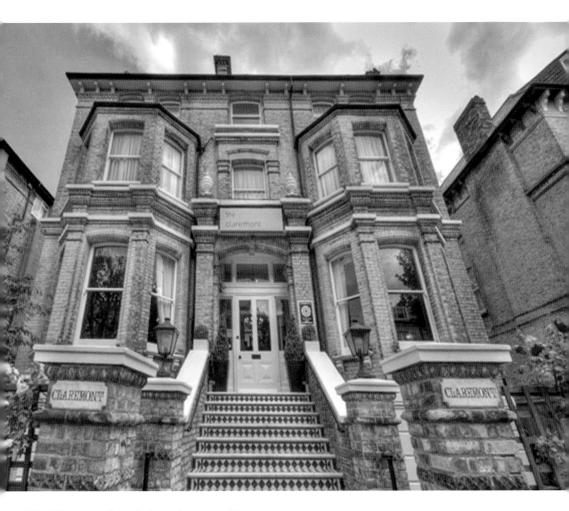

The Claremont School, Second Avenue, Hove
Hove had a wealth of small private schools in the nineteenth and early twentieth centuries, but one deserves featuring in this book due to its uniqueness. The Claremont School started up in Second Avenue, Hove, in 1925, taking its name from Claremont House, which the school leased. Nothing special so far, but when you discover the senior partner behind the new school – James Bernard Clifton – was in fact eleven years old then it makes Claremont a school unlike any other. The school lasted in the premises long after Master Clifton graduated and went on to a sparkling career in the navy and as an engineering inventor, moving to St Michael's Hall and then to Berkshire during the war. The school is still going strong today. In its early days the streets of Hove were the pupils' playing fields and the sea their site for swimming lessons, which were given by Herbert Marshall, Hollywood heartthrob and one-legged veteran of the First World War. Nothing about Claremont School's early days is typical, and the story of the school is a fascinating one. (Author's collection)

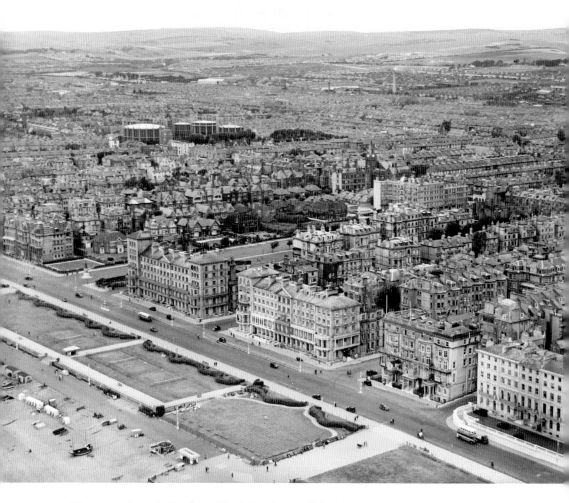

Kingsway, Queen's Gardens, King's Gardens and the Town
Brighton from the south-east, 1937. This is the area used by Claremont School for
cross-country. The beaches here were used by the school's swimming teacher, Herbert Marshall.
(© Historic England Archive. Aerofilms Collection)

Above: National School Building
The National School Building, located on North Road. once (Courtesy of Society of Brighton Print Collectors)

Right: The School for Blind Boys
The Blind Asylum, also known as the School for Blind Boys, was designed by the architect G. Somers Clarke in 1861. It was demolished in the 1950s. Here we see the exterior view of the front façade on Eastern Road. (Historic England Archive)

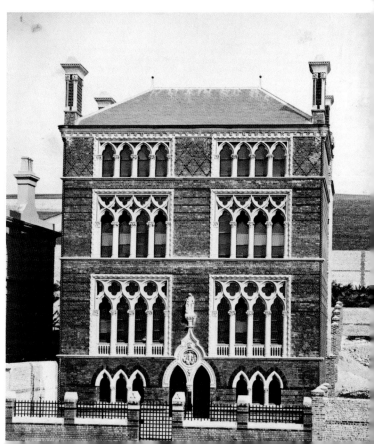

Brighton College
Today one of the most prestigious schools in the country, the first century of Brighton College's existence was riddled with difficulties and its future at times has been far from certain. What follows is a range of shots of the school taken before the Second World War, presumably for a prospectus. The college has always led the way with science, and it is good to see the images kick off with a collection of artefacts and taxidermy mounts, then we see one of the dormitories. In Brighton College's earliest days, its adverts seem amazing to our eyes and ears: in 1845 they were proud of the fact that their fees included 'a separate bed' for each boy. This hadn't always been the case back before the 1840s when it had been absolutely normal for boys to sleep two or more to a bed. We finish our journey through Brighton College's past in the 1920s/1930s with a peek at the main classroom range and an actual classroom, which is today part of the library.

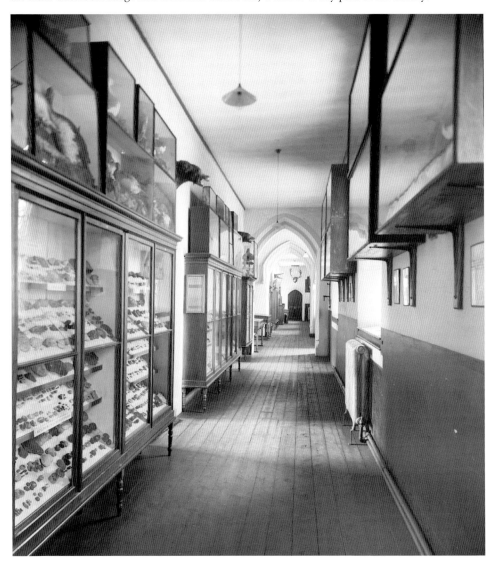

Interior view of a corridor lined with display cases at Brighton College. (Historic England Archive)

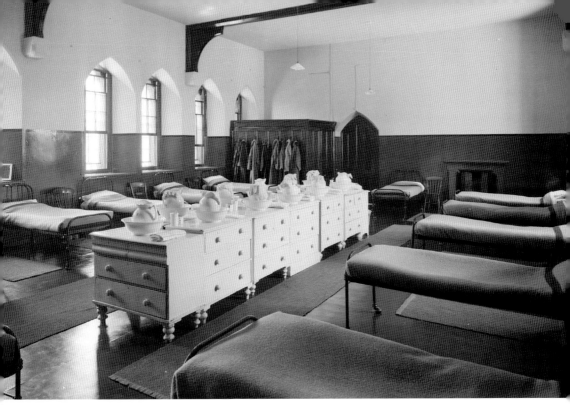

Above: Interior view of a dormitory at Brighton College. (Historic England Archive)

Below: Interior view of the Great Hall at Brighton College, looking towards the stage. (Historic England Archive)

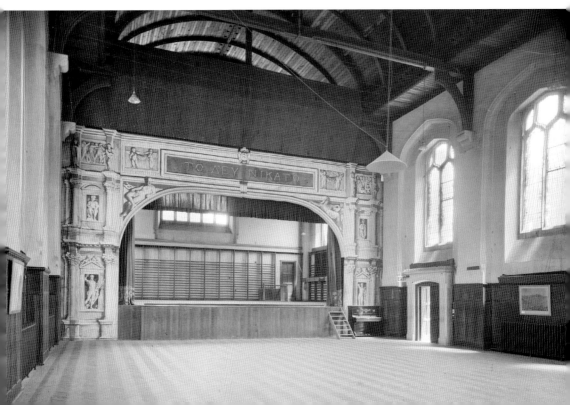

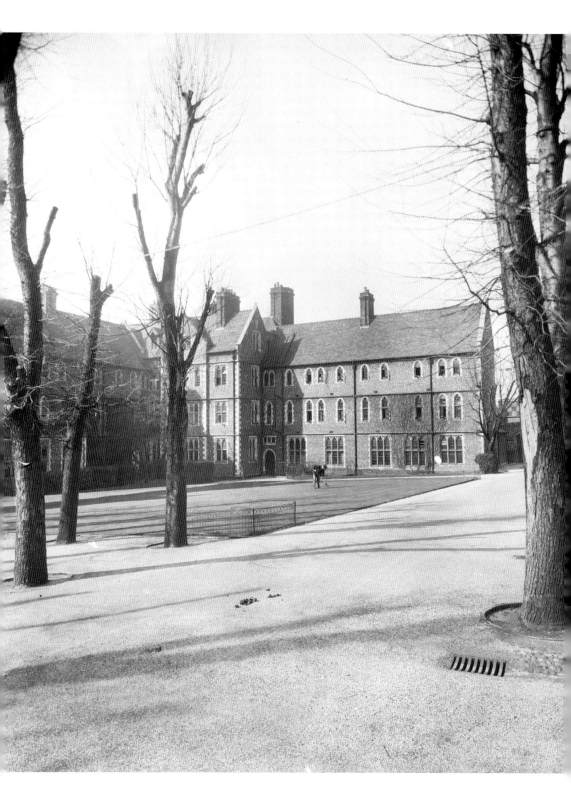

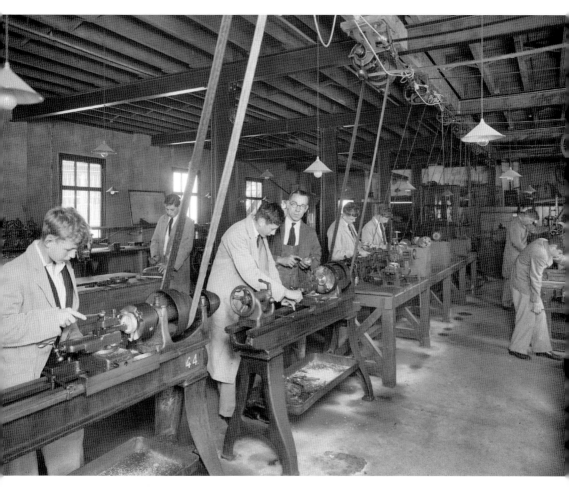

Above: Pupils operating lathes in a technology class at Brighton College. (Historic England Archive)

Opposite above: A view looking south-west across The Quad at Brighton College, with a gardener raking the lawn. (Historic England Archive)

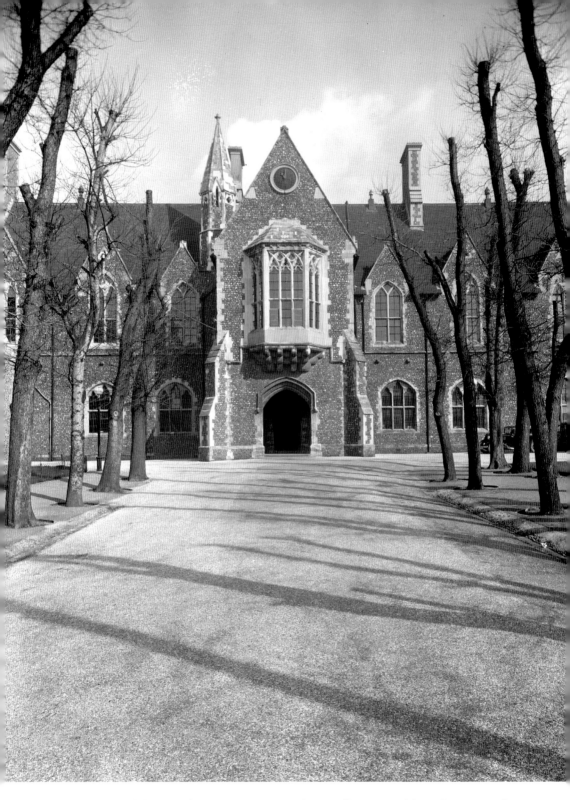

The porch of the main classroom range at Brighton College, viewed from the avenue of trees to the south-west. (Historic England Archive)

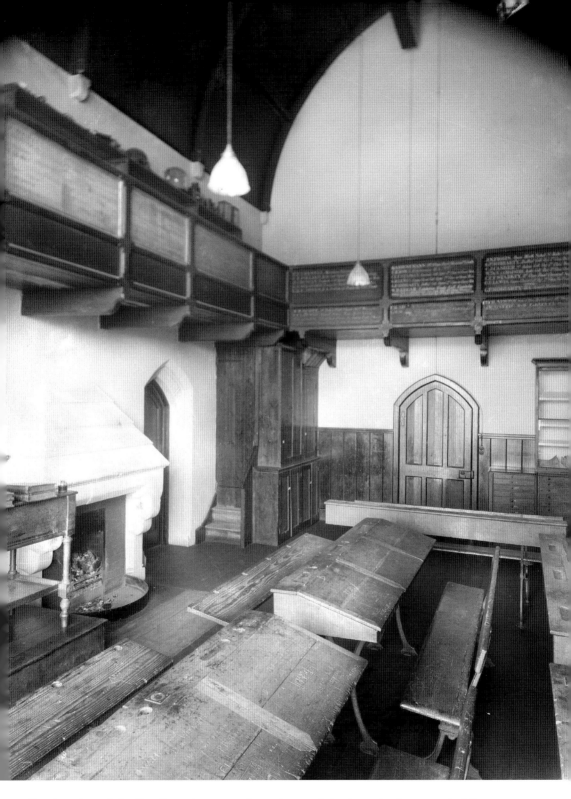

Interior view of the first-floor classroom above the porch in the main classroom building at Brighton College. (Historic England Archive)

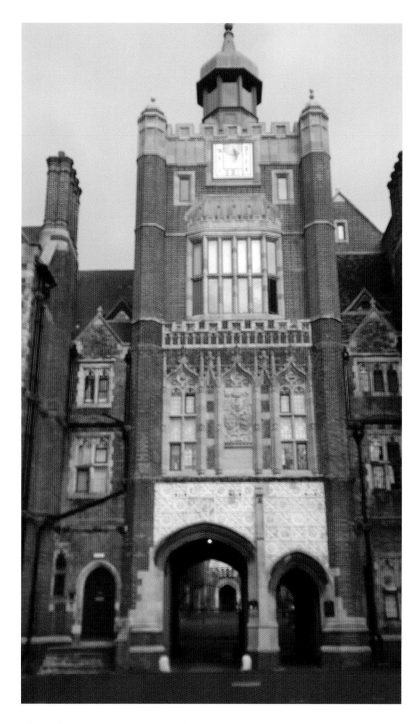

The college entrance today. (Author's collection)

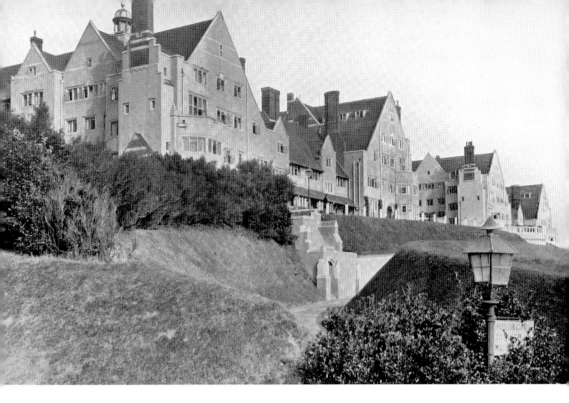

Above: Roedean
In this view of Brighton's most famous and prestigious girls' school we are looking from the south-west at the grand frontage of the establishment, which originated in Kemp Town. This image appeared originally in the 1927 book *Roedean School* by L. C. Cornford and F. R. Yerbury. (Historic England Archive)

Below: Lewes Crescent/Sussex Square House
This is where Roedean began, as Wimbledon House School. (Author's collection)

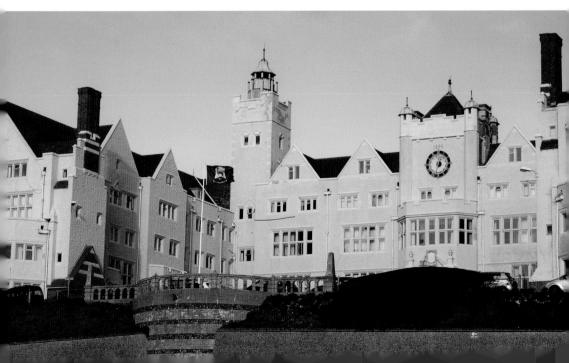

The orginal Roedean site. (Author's collection)

Places Lost

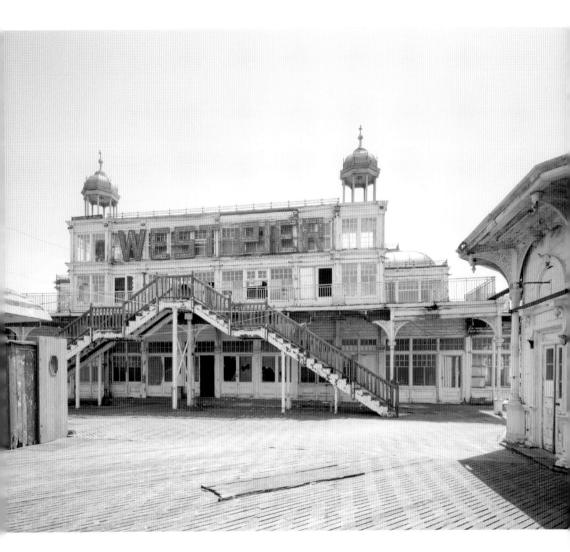

The West Pier

Brighton's greatest loss this century must be that of the West Pier. As late as the early 2000s walks were still possible on the pier on special occasions, but with a hair-raising walk across a temporary platform and with the necessary hard hat. In the first picture we have the exterior of the pier's theatre, which was an amusement center in the pier's dying years. The second shows the pier's western kiosk and precarious landing platform. (© Crown copyright. Historic England Archive)

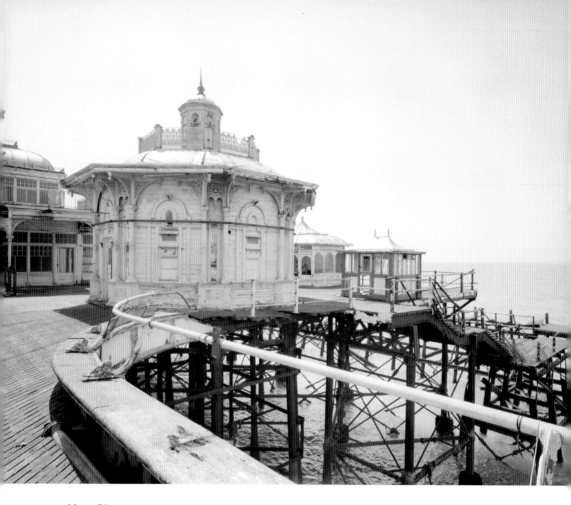

Hove Pier

Hove once had plans for its own pier to rival Brighton's, with the chosen site located opposite Adelaide Crescent. The plans were drawn up in 1864 and, being Hove, it was originally to be ornamental rather than for entertainment. The Brunswick Square commissioners were originally in favour, but changed their minds by 1865. Hove didn't give up, though, and more plans were proposed in 1887, 1892, 1911, 1914, 1923, 1930 and finally in 1932; however, the proposed location changed, with another site proposed between Forth Avenue and Albany Villa. The 1930 plan wanted the pier to be opposite Sussex Road. The pier, had it been built, could have had some amazing features. It was to give Hove its own first theatre and a health spa below the pier. There would be hydroelectric baths, electric light and X-ray treatments. The Pump Room would supply mineral waters from every spring in England and abroad – obviously Hove's seawater wouldn't do! Most grandly, there was to be an electric tramway running from the shore to the end of the pier. (Historic England Archive)

Above and overleaf: The Lost Italian Gardens, Hotel Metropole

One of the Metropole's selling points when it opened in 1890 was its exclusive and secluded Italian Gardens behind the hotel, which included a lake, bridge and illumination at nighttime for the courting couples who were frequenting the hotel. Boasting a garden at the rear was also a selling point for fragile Victorian ladies for whom the sounds of the waves to the front of the hotel were all too much for their delicate constitutions to take. Today the idea of travelling to the sea and then ignoring it seems a ridiculous notion, but the hotel was providing for gentlemen and women of the upper classes early on and accommodating their needs. Here we see the eastern side of the gardens with a group from an organisation called 'LIAT'. These seem to have disappeared from the records, but Historic England's archive inform us that this shot was ordered by the AA organisation, so possibly the Ladies' Independent Automobile Trust, judging by the number of women in the picture and the hotel's motoring connections. With Alfred Vandebuilt, the millionaire horse owner, using the hotel as his starting point for his horse-and-carriage service and his later support for motorised ambulances for the First World War, it may be that this is an early part of that campaign. The Clarence Rooms behind the group here were the hotel's multipurpose function suite: hotel chapel, ballroom and dancehall. This Alfred Waterhouse-designed building still exists today at the hotel, although renamed the Clarence Suite, surrounded by 1960s and 1970s exhibition suites, and the gardens are all built over. Our second image (overleaf below) shows the Clarence Building in full and the third (overleaf above) shows a view looking north-west across the gardens towards the north-western wing of the hotel complex – another lost view. (Historic England Archive)

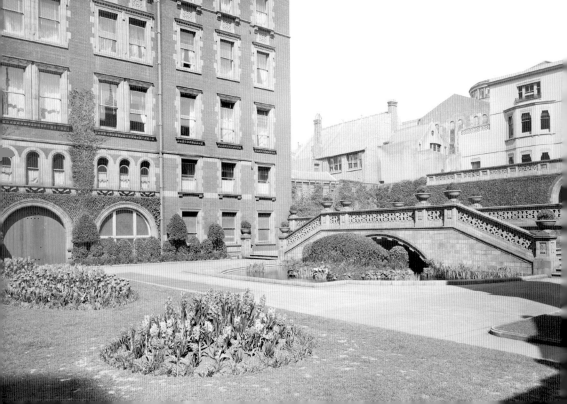

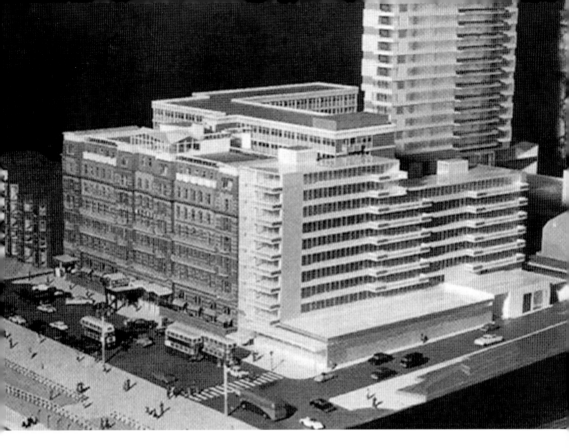

Proposed Metropole Development

Multimillionaire Harold Poster, owner of vinyl panelling empire AVP, purchased the Metropole in 1959. He would go on to also buy the Bedford and Norfolk hotels, and the West Pier. Recognising the Metropole needed a rebuild in its seventieth year, he returned it to profitability with flats and a rooftop restaurant, a massive extension to the rear, an underground car park and the dominating Sussex Heights tower block, the highest of its kind in Sussex. Sensing the need that would nearly two decades later be filled by the Brighton Centre, he marketed the massive function rooms that were built over the Italian and Winter Gardens at the hotel's rear as 'Exhibition Centre Brighton'. This proposal was to develop the centre further, continuing the Sussex Heights style on an east wing of the hotel. This was thankfully never built and instead a 1980 extension was much more sympathetic to the hotel's red brick and terracotta. Like this plan, however, it would mean the Metropole lost its symmetrical front. (Author's collection)

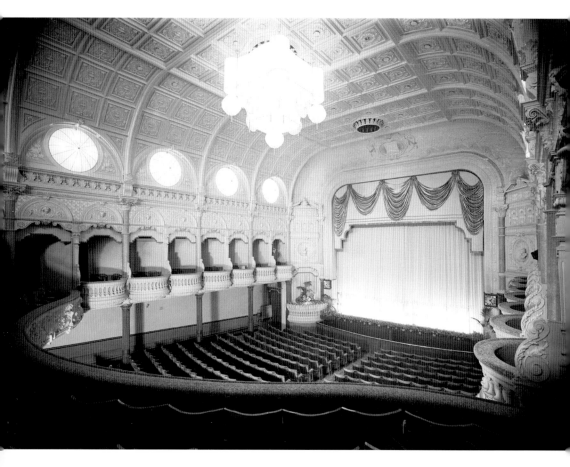

Above, opposite and overleaf: The Palladium Cinema/King's Road/Russell Street Odeon

Out of all the buildings we once had and have lost, one of the most lamented replacements is the Palladium cinema on the seafront. It also had an entrance from Russell Street and was briefly, in 1936–37, an Odeon. The site is now the Brighton Centre (built in 1977), which today is awaiting replacement by a new exhibition and concert centre at Black Rock. The site has been successively redeveloped over the last century with buildings of varying architectural styles. The second image shows changing tastes of the lost theatre interior as a comparison to the existing modernist building, the Brighton Centre. Our final image (overleaf) shows the entrance foyer in its heyday as an Odeon. (Historic England Archive; Author's collection)

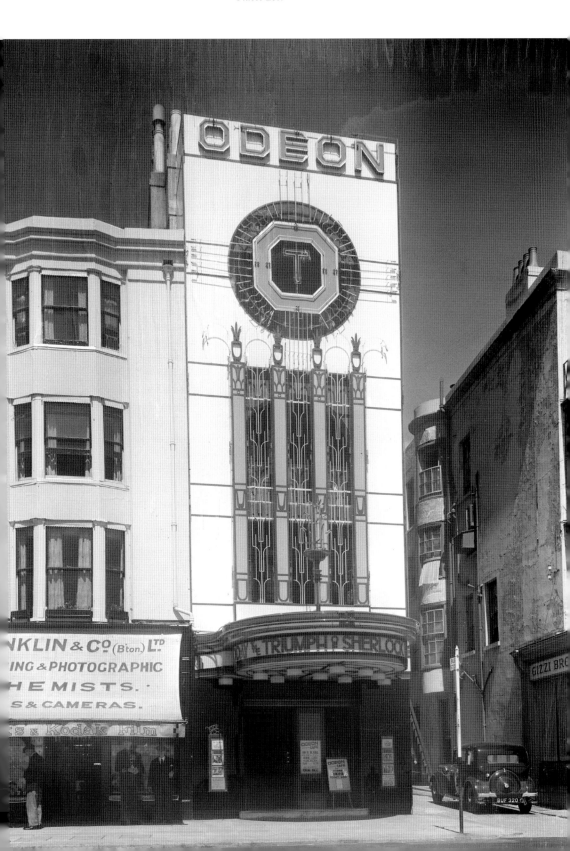

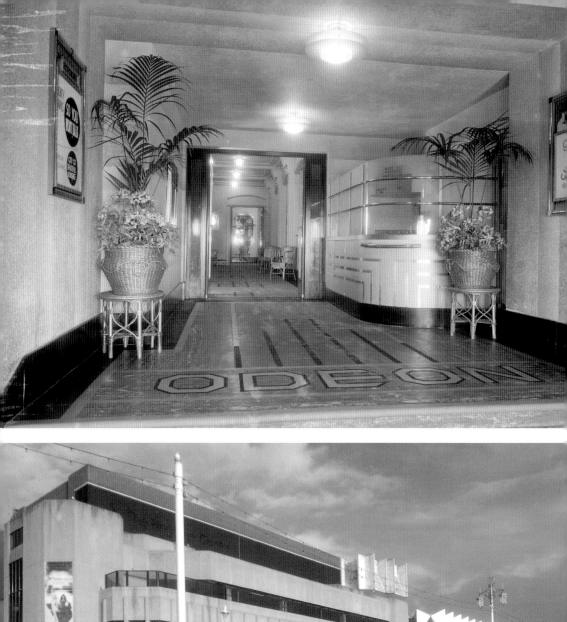

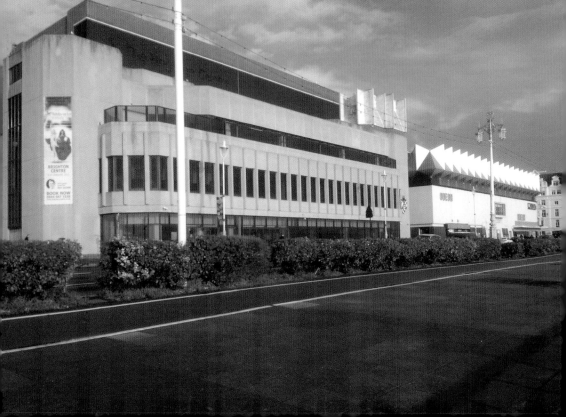

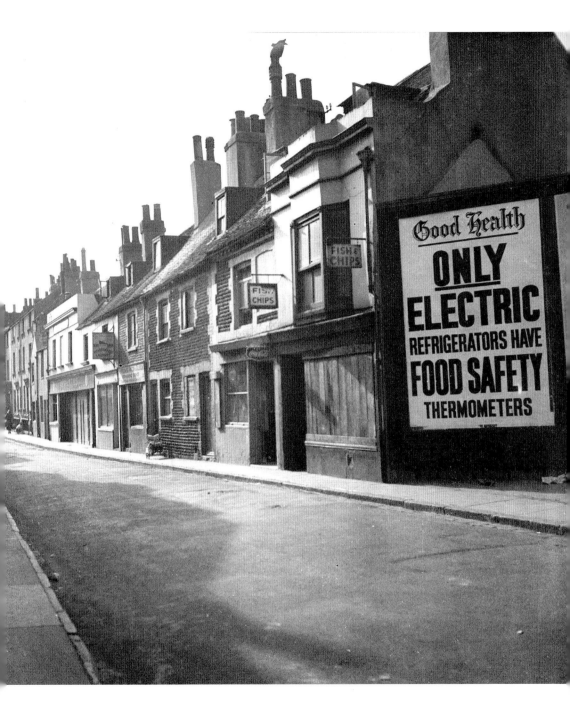

Good Health
ONLY
ELECTRIC
REFRIGERATORS HAVE
FOOD SAFETY
THERMOMETERS

FISH & CHIPS

FISH CHIPS

Russell Street
Up the side of the Palladium/Odeon and now mostly covered over by the Brighton Centre, Russell Street gives us an idea of the communities that existed in this part of Brighton before the building of huge complexes like the Brighton Centre and Churchill Square. Note the food hygiene advertisement of 1938. (Historic England Archive)

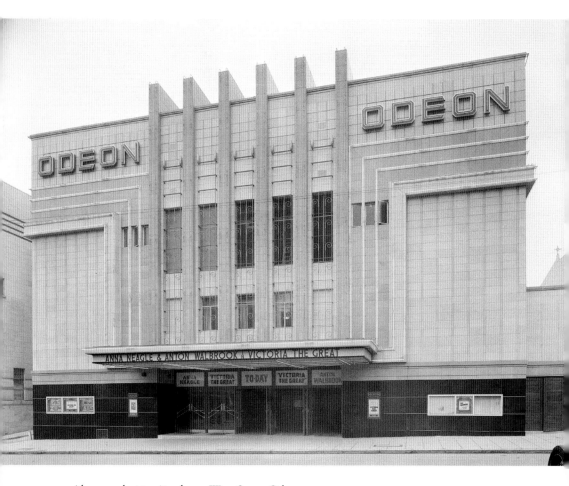

Above and opposite above: West Street Odeon

West Street still boasts an Odeon today, in the Kingswest Building shown on the corner of King's Road and West Street. Here (above) we see the older Odeon, which existed solely in West Street. Like the previous example, it also existed in a modernist-style building with more art deco touches and less of the brutalism shown in the current 1960s building. This was one of two (briefly three) Odeons (the name stood for 'Oscar Deutsch entertains our nation'), the other being in Kemp Town until its bombing in the Second World War. This photo is logged as having been taken between 1930 and 1939, so it was presumably around 1937, after the cinema opened. It was situated next to the SS Brighton, a sports complex and ice rink. The cinema had 1,350 seats, with prices ranging from 1*s* 9*d* to 4*s* 6*d* for a continuous performance. The Odeon closed in 1973 and the building stood vacant until its demolition in 1990 when it was replaced by a hotel. (Historic England Archive; Author's collection)

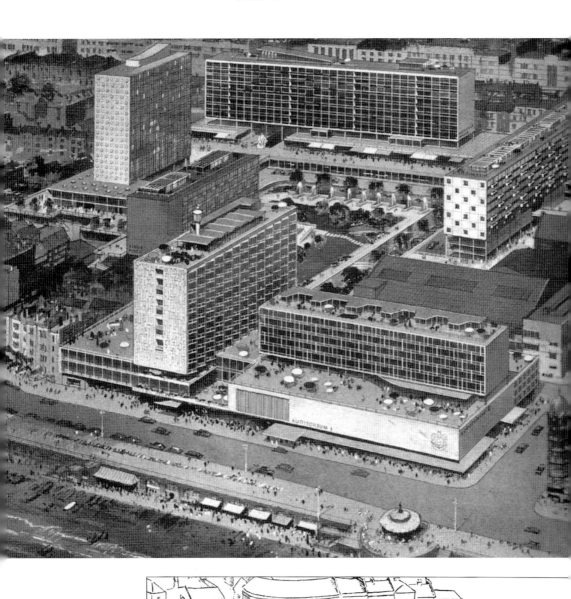

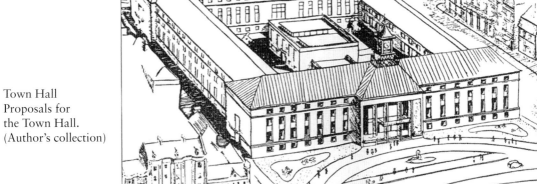

Town Hall
Proposals for
the Town Hall.
(Author's collection)

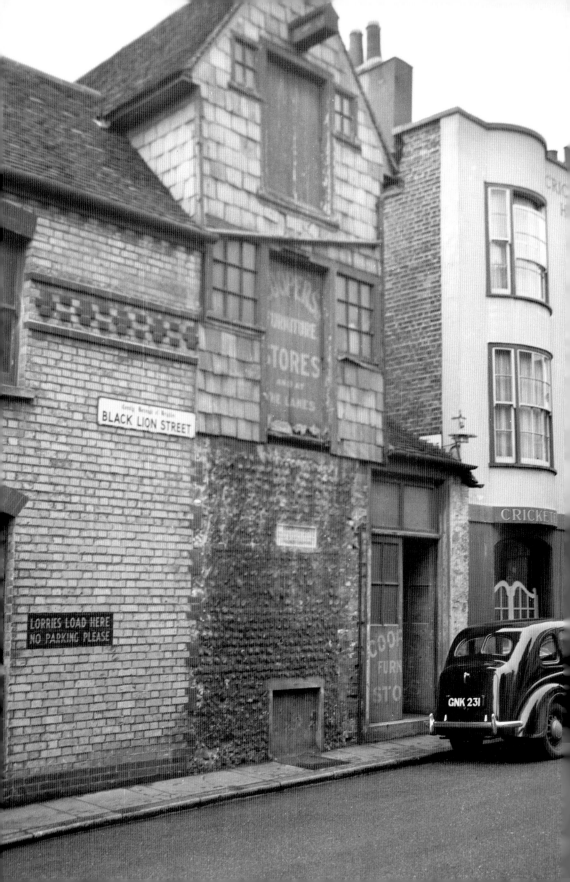

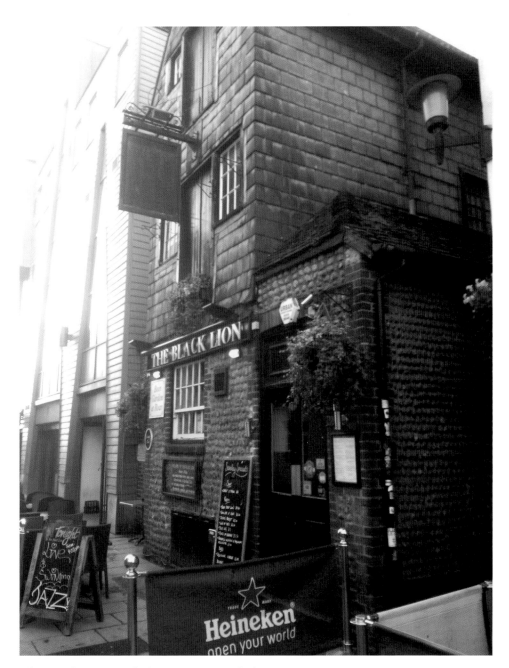

Above and opposite: Black Lion Brewery, Black Lion Street
At first glance this may look similar to the current Black Lion pub, but this is the original brewery that was demolished in the 1970s, dating back to the Tudor era and Flemish brewer and Marian martyr Deryk Carver. The building today is a reconstruction of the original using Brighton's historic use of materials and characterful vernacular style. Shown here in 1952, it is a reminder of how Brighton was a home to this industrious immigrant community. (Historic England Archive; Author's collection)

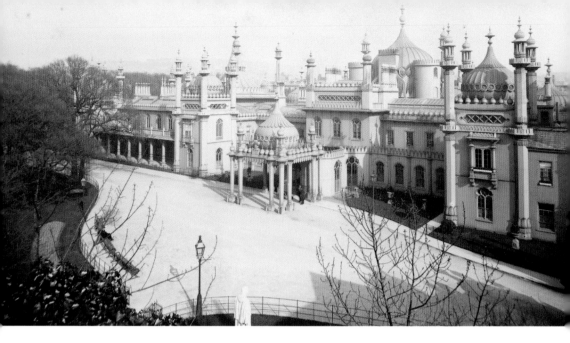

Above and below: East Street

Here (above) we see the original route of East Street, which was diverted by the prince regent when he developed the Pleasure Grounds to the west of the pavilion to construct New Road by 1805. East Street remains here as a private road in the last decades of the nineteenth century, but without the traffic that would have passed so near to the palace. Today the road has been further reduced and the pavilion has the original layout its gardens would have had in the prince's time. East Street passed through the pavilion grounds, originally joining up with Victoria Gardens where the North Gate now is. This wasn't the only reorganisation the prince demanded. A street was demolished towards the north of the grounds, the Castle Inn was purchased and demolished, and the Chapel Royal moved to its current location in North Street. The second image (below) shows the south entrance to the pavilion from East Street as it looked pre-First World War. The Indian Gate would be built here in 1921 as a gesture of thanks from the people of India to the people of Brighton for caring for the approximately 12,000 Indian troops who were treated here during the First World War. (Historic England Archive)

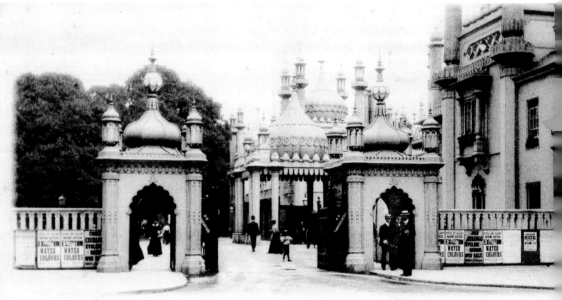

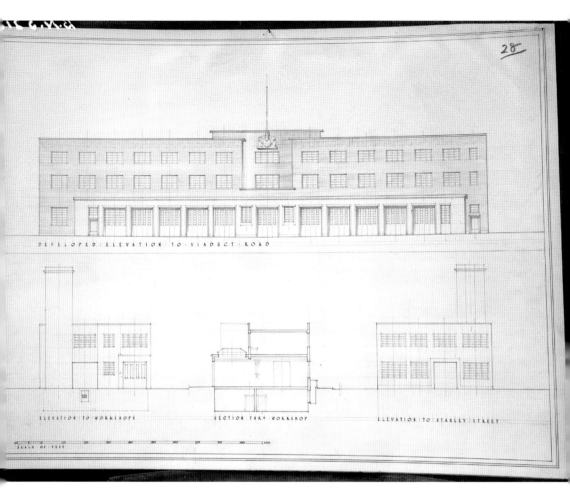

Above and overleaf above: Preston Circus Fire Station
Here we have a look at how the fire station, dominates much of this busy North Brighton junctions could have looked very different. This is a photograph of a measured drawing showing elevations and sections of the proposed new fire station. The drawings were created as part of a competition to redesign the fire station on Preston Circus. The competition was won by Graeme Highet. The first design was the second-placed entry and featured in *The Architect and Building News* in 1937. So did the second image (overleaf above), but it only achieved third place. (Historic England Archive)

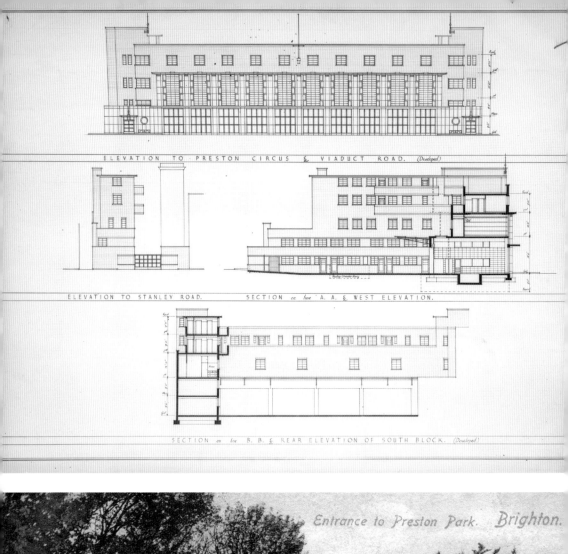

ELEVATION TO PRESTON CIRCUS & VIADUCT ROAD. (Developed)

ELEVATION TO STANLEY ROAD. SECTION on line 'A. A. & WEST ELEVATION.

SECTION on line B. B. & REAR ELEVATION OF SOUTH BLOCK. (Developed)

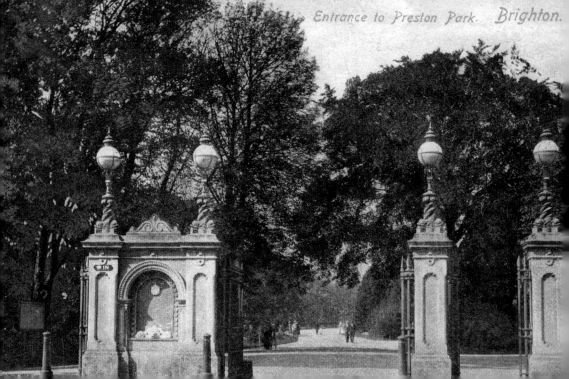

Entrance to Preston Park. Brighton.

Above and opposite below: Preston Park

It seems strange today to think of parks as areas of Brighton that were surrounded by fences, patrolled by park keepers and with access dependent on the gates being opened. Until the demands for scrap metal during the Second World War, our parks were indeed enclosed as we see here (opposite below), with the one-time entrance to Preston Park that existed at the Stanford Avenue end. The grand entrance here is almost a reminder that the areas of what are now our municipal parks and recreation spaces were once the private lands of the Western and Stanford families. (Historic England Archive; Author's collection)

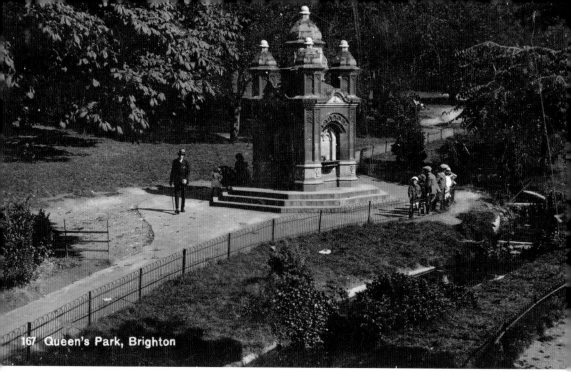

167 Queen's Park, Brighton

Above and left: Queen's Park Water Fountains
With our recent return to refillable, reusable drinking beakers and the move away from single-use plastic bottles, it may be that water fountains such as this elaborately decorated terracotta and red brick one may become much used again in Brighton's parks. Here (above) we see the fountain in its early years. Hopefully such a glorious piece of our park architecture can be restored once again. (Historic England Archive; author's collection)

Opposite: Odeon Cinema, Kemp Town
Another photo of this cinema, seen here bedecked in bunting for George VI's coronation in 1936. The main show is the film *Song of Freedom* staring Paul Robeson who was an American singer, actor and civil rights activist. Robeson was one of the first black performers to achieve world renown. Importantly *Song of Freedom* gave him a prominent and serious role, and, notably, he dictated the film's final cut, which was extraordinary for any actor at that time. This cinema would only have a short life before its bombing by the Luftwaffe in 1940. Today it is residential sheltered housing (seen here). (Historic England Archive)

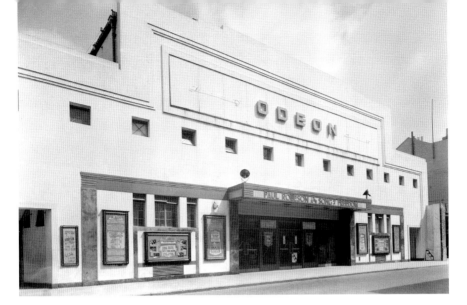

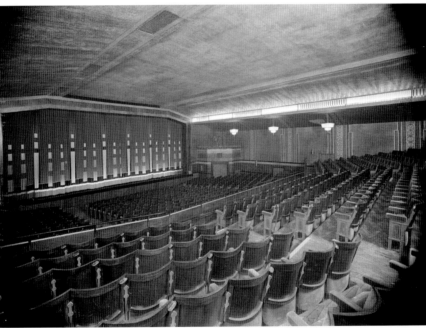

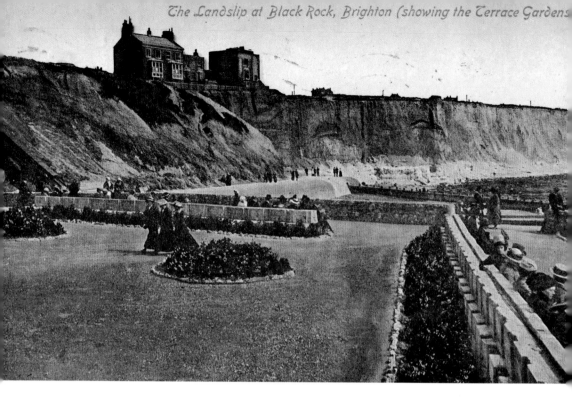

Above and below: Black Rock

It seems hard to imagine the beach east of Brighton today that is Brighton Marina – practically a town within the city. Black Rock was once a tourist destination in its own right its rock pools, scenic cliffs, inn on the cliffs above and its cave. Magnus Volk, whose railway went and still goes to Black Rock, even hinted that the area was a smugglers' beach to aid his passenger numbers. The rumours were probably based on the tunnel that was excavated in the 1820s, which gained the reputation of a smugglers' tunnel but was actually for the construction of Kemp Town, whose wealthy residents would have been appalled by the 'freetrading' classes being in their proximity. This postcard from the second decade of the twentieth century commemorates a landslip occurring. (Historic England Archive; author's collection)

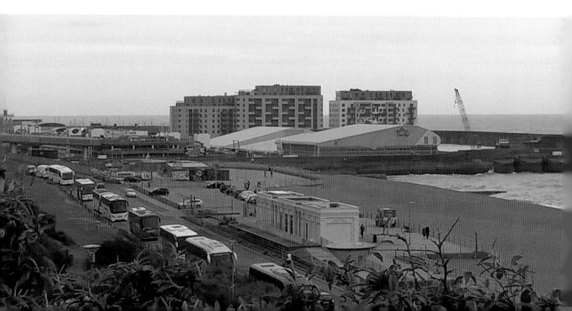

Acknowledgements

I am most grateful to Angeline Wilcox at Amberley for commissioning the book and for her willingness to help and always answer the daftest of questions or chew over barmy proposals. Also to Jenny Stephens and Becky Cousins at Amberley for their work on the design of the book. Thanks also to Alyson Rogers at Historic England Archives for support when the website hit some gremlins in the early days of the project and for successfully sorting things out. Finally, my heartfelt thanks and love go as always to my family, Laura, Seth and Eddie, for their patience, support and encouragement.

About the Author

Kevin Newman is a Sussex author, tour guide and historic events organiser who has written five books for Amberley before this one. He has also written school history resources and textbooks and contributes history supplements to the *Argus* newspaper in Sussex, as well as to *Sussex Life*, *Exclusively British* magazine and for Brighton and Hove Albion FC publications. His next book for Amberley is *A–Z of Brighton & Hove*.

Walking and Motorised Tours of Sussex

For historic Sussex talks and walking or motorised tours, please call All-Inclusive History on 07504 863867 or email info@allinclusivehistory.org. Other tours are available, including 'Saucy Sussex', 'Silly Sussex' and 'Spooky Sussex'. All-Inclusive History also run a range of Sussex and Brighton-based events for businesses, organisations and schools.

Further Reading

Argus, Evening Argus Archives.
Armstrong, J. R., *A History of Sussex* (Phillimore, 1978).
Arscott, David, *Curiosities of West Sussex* (S. B. Publications, 1993).
Arscott, David, *The Sussex Story* (Pomegranate Press, 1998).
Antill, Trevor, *The Monarch's Way Book 3: The South Coast, The Downs…and Escape!* (Meridian Books, 1995).
Barr-Hamilton, Alex, *In Saxon Sussex* (Arundel Press, 1953).
Boyd, R. M., *Alfriston* (Goldleaf Partnership, 1989).
Brandon, Peter and Short, Brian, *The South East From AD 1000* (Longman, 1990).
Bryson-White, Iris, *History, People and Places in East Sussex (*Spurbooks, 1978).
Bunt, Peggy, *Viewing Sussex Series – Sussex Long Ago* (Warne, 1976).
Coppin, Paul, *101 Medieval Churches of East Sussex* (S. B. Publications, 2001).
Fraser, Antonia, *King Charles II (Part One)* (Orion, 2002 edition).
Gray, James S., *Victorian & Edwardian Sussex From Old Photographs* (Batsford, 1973)
Green, Claire, *Portslade: A Pictorial History* (Phillimore, 1994).
Guy, John, *Castles of Sussex* (Philimore, 1984).
Harris, Roland B., *Brighton and Hove – Historic Character Assessment Report – Sussex Extensive Urban Survey* (Brighton and Hove City Council, 2007).
Harris, Roland B., *Lewes – Extensive Urban Survey* (Lewes District Council, 2005).
Harrison, David, *Along the South Downs* (Cassell, 1958).
Jamieson, Susan and Gina, *Old-Fashioned Days Out in Sussex* (Snake River Press, 2009).
Kramer, Ann, *Sussex Women – A Sussex Guide* (Snake River Press, 2007).
Lang, Sean, *British History For Dummies* (Wiley, 2011).
Long, David, *Bizarre England* (O'Mara, 2015).

Longstaff-Tyrrell, Peter, *Front-Line Sussex: Napoleon Bonaparte To The Cold War* (Sutton, 2000).

Lucas, E. V., *Highways and Byways In Sussex* (1903).

Mais, SPB, *Sussex* (Richards Null, 1937).

Manley, John, *Atlas of Prehistoric Britain* (Phaidon, 1989).

McCarthy, Edna, and Mac, *East Sussex – 28 Walks Reprinted From The Evening Argus Weekender* (Southern Publishing Company – Westminster Press, 1984).

Nairn, Ian and Pevsner, Nikolaus, *The Buildings of England – Sussex* (Puffin, 1965).

Newman, Kevin, *50 Gems of Sussex* (Amberley Publishing, 2017).

Newman, Kevin, *Brighton & Hove in 50 Buildings* (Amberley Publishing, 2016).

Newman, Kevin, *Brilliant Brighton* (*Argus*, 2016).

Newman, Kevin, *Secret Brighton* (Amberley Publishing, 2016).

Newman, Kevin, *Super Sussex* (*Argus*, 2017).

Newman, Kevin, *Visitors' Historic Britain: East Sussex/Brighton and Hove* (Pen and Sword, 2018).

Newman, Kevin, *Visitors' Historic Britain: West Sussex* (Pen and Sword, 2018).

O'Callaghan, Paul, *East Sussex Coastal Railways Volume 1: The Ashford to Brighton* Line (S. B. Publications, 2011).

Ollard, Richard, *The Escape of Charles II* (Robinson, 2002).

Parsons, David and Milner-Gulland, Robin, *Churches and Chapels of the South Downs National Park* (Sussexpast, 2017).

Pennington, Janet, *Chanctonbury Ring: The Story of a Sussex Landmark* (Downland History Publishing, 2011).

Reynolds, Kev, *Walking In Sussex: Long-Distance and Day Walks* (Cicerone, 2004).

Thomas-Stanford, Charles, *Sussex in the Great Civil War* (Chiswick, 1910).

Venning, Timothy, *The Kings & Queens of Anglo-Saxon England* (Amberley Publishing, 2013).

Victoria County History, 'Sussex' – various.

Vine, Paul, *Kent & East Sussex Waterways* (Middleton, 1989).

Waugh, Mary, *Smuggling in Kent & Sussex 1700–1840* (Countryside Books, 1985).

Willard, Barbara, *Sussex* (Batsford, 1965).

Willy, Frank and Dale, Judith *A Short History of Hove* (East Sussex County Council, 1978).

Newman, Kevin, Walsh, Aaron, Holmes, Jon *AQA GCSE History: Thematic Studies* (Oxford, 2016).

About the Archive

Many of the images in this volume come from the Historic England Archive, which holds over 12 million photographs, drawings, plans and documents covering England's archaeology, architecture, social and local history.

The photographic collections include prints from the earliest days of photography to today's high-resolution digital images. Subjects range from Neolithic flint mines and medieval churches to art deco cinemas and 1980s shopping centres. The collection is a vivid record both of buildings that are still part of everyday life – places of work, leisure and worship – and those lost long ago, surviving only in fragile prints or glass-plate negatives.

Six million aerial photographs offer a unique and fascinating view of the transformation of England's towns, cities, coast and countryside from 1919 onwards. Highlights include the pioneering photography of Aerofilms, and the comprehensive survey of England captured by the RAF after the Second World War.

Plans, drawings and reports provide further context and reconstruction artworks bring archaeological sites and historic buildings to life.

The collections are housed in a purpose-built environmentally controlled store in Swindon, which provides the best conditions to preserve archive items for future generations to enjoy. You can search our catalogue online, see and buy copies of our images, as well as visiting our public search room by appointment.

Find out more about us at HistoricEngland.org.uk/Photos
email: archive@historicengland.org.uk
tel.: 01793 414600

The Historic England offices and archive store in Swindon from the air, 2007.